Contents

The Salon of 1846

The Salon of 1846
Charles Baudelaire

David Zwirner Books

ekphrasis

Translated by Jonathan Mayne

Introduction

Michael Fried

Charles Baudelaire's *Salon of 1846* is one of the most brilliant and original pieces of sustained art criticism ever written.[1] When Baudelaire wrote it he was twenty-five, with one more modest *Salon*, that of 1845, behind him. ("Salons" were called that because they were reviews of exhibitions originally held in the Salon Carré, the "square room," of the Louvre; by Baudelaire's time, the number of works on view had grown significantly, with the result that more than one room was required to house them all, but the name for both the exhibitions and the reviews had come to stick.)

Baudelaire's achievement is all the more impressive in that the exhibition of 1846 was in no way outstanding. Of the two most prominent painters of the day, Jean-Auguste-Dominique Ingres had not been showing in Salons for more than a decade, and his still controversial younger contemporary Eugène Delacroix, then at work on the decorative project of the library of the Palais Bourbon, was represented by a few relatively minor works; significant landscape painters such as Jean-Baptiste-Camille Corot and Constant Troyon had pictures on view, but landscape as such was far from central to Baudelaire's thought. Indeed, commentaries on individual works, traditionally the staple of Salons as critical performances, play a limited role in Baudelaire's text. So in what exactly does its undeniable distinction lie?

The simplest answer is that from first sentence to last (no exaggeration, as will become clear) the *Salon of 1846* presents a singularly comprehensive and intellectually

ambitious account not just of the current situation of the enterprise of painting in France but also, equally important, of the task and possibilities of art criticism. (Also, more broadly, of the conditions of modernity as Baudelaire experienced them.) In part this reflects the young Baudelaire's understanding of a certain tradition within the genre of art criticism, going back to the initiatory genius of the eighteenth-century philosophe Denis Diderot and including a remarkable list of literary figures, among them Stendhal, whom Baudelaire cites and clearly admired, and his older contemporary Théophile Gautier, to whom he would dedicate *Les Fleurs du mal*. Put slightly differently, largely owing to the numinous example of Diderot, the founder of modern art criticism in his dazzling *Salons* of the 1760s, the genre itself had come to play a major role in French intellectual life, and Baudelaire, already the author of extraordinary poems, was anxious to make his mark with a critical and theoretical text that would outdo its predecessors if not in sheer brilliance (Diderot was unsurpassable on those grounds), at any rate in the rigor and manifest ambition of its self-conscious project. What is remarkable is the degree to which Baudelaire succeeded in what he set out to do.

Structurally, the *Salon of 1846* comprises a dedication ("To the Bourgeois") followed by eighteen short sections, each bearing a title. Not all the sections are equally crucial to his overall argument, but taken together they are remarkably consistent; the task of someone like myself who seeks to introduce this deceptively simple-seeming text is

to do justice to that consistency as well as to the particular vision of painting and criticism it attempts to convey.

A great deal of critical, historical, and theoretical work is done in an almost offhand manner in the first section, "What Is the Good of Criticism?" For example, there we read: "To be just, that is to say, to justify its existence, criticism should be partial, passionate, and political, that is to say, written from an exclusive point of view, but a point of view that opens up the widest horizons." And: "To extol line to the detriment of color, or color at the expense of line, is doubtless a point of view, but it is neither very broad nor very just, and it indicts its holder of a great ignorance of individual destinies." As for the point of view Baudelaire advocates, he characterizes it as "individualisme bien entendu," which I would render as "individualism rightly understood" (as opposed to "an orderly individualism," as in the present translation)—by which he means that he "require[s] of the artist the quality of *naïveté* and the sincere expression of his temperament, aided by every means which his technique provides. An artist without temperament is not worthy of painting pictures, and—as we are wearied of imitators and, above all, of eclectics—he would do better to enter the service of a painter of temperament, as a humble workman. I shall demonstrate this in one of my later chapters." Then, immediately, a one-sentence paragraph:

The critic should arm himself from the start with a sure criterion, a criterion drawn from nature, and

should then carry out his duty with a passion; for a critic does not cease to be a man, and passion draws similar temperaments together and exalts the reason to fresh heights.

The section ends by suggesting that romanticism may be understood as "the most recent, the most modern expression of beauty," which leads to the claim that "for the reasonable and passionate critic, the great artist will be he who will combine with the condition required—that is, the quality of *naïveté*—the greatest possible amount of romanticism."

One could spend many pages unpacking these brief passages. Note, for example, the claim that criticism should be political, a statement that needs to be read in the light of an awareness that in a few years the Revolution of 1848 will convulse France (and other European countries). In the early, February days of the Revolution, Baudelaire will be caught up enthusiastically in its manifestations, only to be definitively disappointed in its outcome, culminating in Louis Bonaparte's coup d'état of December 1851. ("The 2nd December has physically depoliticized me," he wrote in a letter of the time.[2] This was true for others in his generation, such as Gustave Flaubert.) In 1846, however, Baudelaire was anything but sympathetic to the forces of radicalism, as is made explicit later in the *Salon* when he vicariously cheers on a policeman or municipal guard "thumping a republican." The reason, he suggests, is that the republicans are by

virtue of their political commitments indifferent to art, hence his ironic but nevertheless not entirely unserious appeal to the bourgeois in his dedication. The notion of "individualism rightly understood" is thus in part a quasi-political ideal, one with no actual political "home" in the politics of 1846 France but expressive nonetheless of a no doubt vanishingly slim hope—even that may be too strong—that there might yet be a place in the society of his time for Baudelaire's sense of artistic possibility. But of course it is also an "aesthetic" ideal, calling for the artist to be a certain sort of "individual," which is to say a person with a distinct sensibility (or "temperament") of his own (no women artists in his purview) and the determination to express it as forcefully and directly (as "*naïvely*") as possible. In the course of the *Salon* it will become clear that in Baudelaire's view only a handful of contemporary artists fit this bill, with the result that in the absence of schools of painting, a feature of previous ages, an artist had to be truly remarkable, an Ingres or Delacroix (or Corot, or Rousseau) if he was to stand out from the mediocrity of the mass. This is a certain sort of historical claim, to which I shall return.

As regards the statement that the critic should arm himself from the start with a sure criterion, one drawn from nature, it is striking how almost all scholarly commentaries on Baudelaire's *Salon* have avoided taking a stand as to how this is to be understood. (As if he, being a poet, were not to be taken fully seriously.) To my mind, though, it seems clear from subsequent passages that

Baudelaire has in mind the criterion of memory—more accurately, *memorability*—as in the somewhat later statement apropos the issue of color (in particular the quality of melodiousness in color): "The right way to know if a picture is melodious is to look at it from far enough away to make it impossible to understand its subject or to distinguish its lines. If it is melodious, it already has a meaning and has already taken its place in your store of memories." Further on he will say of Delacroix's painting that it "issues above all from the memory, [and] speaks above all to the memory." And still later he will write, "I have already observed that memory is the great criterion of art," although (as the quoted passages show) he had not quite spelled that out.

Nor does the invocation of memory stop there. Of the work of eclectics, who to Baudelaire's disgust routinely combine multiple incompatible manners, he writes that it "leaves no memory behind it." In the same spirit he deplores what he calls "the 'chic' and the 'poncif,'" the first of the two terms indicating "a total neglect of the model and of nature. The 'chic' is an abuse of the memory; moreover it is a manual, rather than an intellectual memory that it abuses—for there are artists who are gifted with a profound memory for characters and forms—Delacroix or Daumier, for example—and who have nothing to do with it." As for the "poncif," it is a similar abuse but one that "applies more particularly to attitudes and to the expressions of the head" (stored in the artist's memory and deployed to no good effect).

Significantly, too, the next section, "M. Horace Vernet," expresses Baudelaire's disdain for that famous artist whose greatest public successes occurred in the field of military painting. Specifically, Baudelaire deplores Vernet's appeal to a crass nationalism, to his emphasis on cacophony rather than color and episodes rather than unity, and perhaps above all for still another abuse of memory according to which Vernet portrays "the correct number of buttons on each uniform, or the anatomy of a gaiter or a boot which is the worse for innumerable days' marching, or the exact spot on a soldier's gear where the copper of his small arms deposits its verdigris." In other words, Vernet possesses "a memory like an almanac!" Indeed, the primacy of effects of memory is the key to the "system" of the *Salon of 1846*, and although there is not space in this introduction to fully pursue the topic, there is no more crucial issue for the reader to be aware of as he or she makes his way through the text. Very roughly: I understand a painting to be memorable in Baudelaire's sense of the term if it somehow succeeds in activating the memory of one or more previous painting of high quality while at the same time not quite allowing such memories to surface explicitly in the viewer's consciousness. My further suggestion is that Baudelaire himself both was and was not in command of this double valence of his argument.[3]

With regard to the invocation of romanticism, this sets the stage for Baudelaire's subsequent remarks on color—a major concern throughout the *Salon*—and,

equally, for his extensive remarks on Delacroix, in his view then and later *the* exemplary painter of the nineteenth century by virtue of "the unique and persistent melancholy with which all his works are imbued, and which is revealed in his choice of subject, in the expression of his faces, in gesture and in style of color.... As you look through the succession of his pictures, you might think that you were assisting at the celebration of some dolorous mystery." More precisely, he defines Delacroix's special province within the empire of painting as "drama, natural and living drama, the drama of terror and melancholy, expressed often through color, but always through gesture." Baudelaire adds: "It is really this fact that establishes the importance of his greatness. Suppose, indeed, that the baggage of one of the illustrious departed were to go astray; he will almost always have his counterpart, who will be able to explain him and disclose his secret to the historian's scrutiny. But take away Delacroix, and the great chain of history is broken and slips to the ground"— another historical claim, itself reason for melancholy, of the sort that no mere historian would quite dare to make. (A preoccupation with melancholy or, as Baudelaire calls it, *spleen* as a distinctively modern mood permeates not just the *Salon* but Baudelaire's entire oeuvre.)

As has always been recognized, Baudelaire's fixation on Delacroix makes him unusual among major art critics in principally championing an artist of an older generation (Delacroix was born in 1798, Baudelaire in 1821). In the late 1850s and early 1860s, Baudelaire became close

to Édouard Manet, but his departure for Brussels in 1864 meant that he never saw the completed *Olympia*, and in any case there were aspects of Manet's art, notably the latter's frequent citations of previous painting, that would have caused him considerable discomfort had he been compelled to take them in. In other respects, too, 1846 seems a late moment to be extolling romanticism, which emerged in France in the 1820s and 1830s: within two years the young Gustave Courbet will step to the fore with his breakthrough canvas, the darkly compelling *After-Dinner at Ornans*, and realism, not romanticism, will become the fighting issue of the day. As scholars have not failed to remark, Baudelaire and Courbet were friends, to the extent of the painter's including a portrait of the poet (and his mistress Jeanne Duval) in his monumental *Atelier du peintre* of 1855. But for Baudelaire, realism could only be understood as a kind of materialist deviation that denied a role for the imagination, the supreme Romantic value, which is to say that he held himself apart from the most progressive art of his generation. Eventually, in his stunning late text *The Painter of Modern Life*, his exemplary figure will be the older illustrator Constantin Guys, whose achievement sidesteps the very enterprise of ambitious painting. Exactly how all this is to be understood remains an open question for students of Baudelaire's criticism.

And something else. It's easy to glide past the opening phrases, "To be just, that is to say, to justify its existence, criticism should be partial, passionate, and political," or

in the next passage cited, the statement that to extol line or color at the expense of the other "is doubtless a point of view, but it is neither very broad nor very just," without pausing over the appeal to the epithet "just." Looked at closely, the word may seem odd, a curious choice. Until one recalls the opening sentence of the dedication to the Bourgeois: "You are the majority—in number and intelligence; therefore you are the force—which is justice." Force and justice: for the French reader, at any rate, this should touch a nerve, the two terms having been juxtaposed with one another in one of Blaise Pascal's best-known, indeed somewhat notorious, *pensées*. As follows:

> It is just that what is just should be obeyed; it is necessary that what is strongest should be obeyed. Justice without force is helpless. Force without justice is tyrannical. Justice without force is futile, for there will always be the wicked. Force without justice is condemned. It follows that we must bring together justice and force and, to this end, make what is just strong, or what is strong just.
>
> Justice is subject to dispute. Force is instantly recognizable and beyond dispute. Therefore one cannot give force to justice, because force has contradicted justice and has said that it, force, was just. And so, not being able to make justice strong, we have made that which is strong just.[4]

Again, this is not the place for an extended discussion of Pascal's trenchant if not searing text, the ethical and the political implications of which have been the focus of intense interest on the part of commentators. For our purposes, what matters is that the mobilization of Pascal reveals another facet of Baudelaire's intellectual ambition in the *Salon of 1846*, by which I mean not simply that he makes Pascal's formidable *pensée* the basis for political and aesthetic reflection but also that by doing so he extends the reach of his own thought into the area of religion, Pascal being one of the most profound intellects in the French Catholic, more precisely Jansenist, tradition. (The religious resonances of *Les Fleurs du mal* are of course widely recognized.)

And in fact religious rhetoric will surface toward the end of the *Salon*, when Baudelaire contrasts the feeling of profound unity that marks earlier moments in artistic history as glimpsed in a museum with the cacophony of styles and manners in a modern Salon. He goes on to observe, "*Then* you had schools of painting; *now* you have emancipated journeymen. There were still schools under Louis xv; there was one under the Empire—a school—that is, a faith—that is, the impossibility of doubt." And: "Doubt, or the absence of faith and of *naïveté*, is a vice peculiar to this age, for today no one is obedient, and *naïveté*, which means the domination of temperament within manner, is a divine privilege which almost all are without." (No one has ever dreamed of defending Baudelaire against the charge of elitism.) As for

those lacking that privilege, the mediocre "apes" of art as Baudelaire calls them, they "[are] lost, for [themselves] and for all mankind." He continues:

> That is why it would have been more in the interest of their own salvation, and even of their happiness, if the lukewarm had been subjected to the lash of a vigorous faith. For strong men are rare, and today you have to be a Delacroix or an Ingres if you are to come to the surface and be seen amid the chaos of an exhausting and sterile freedom.
>
> The apes are the republicans of art, and the present state of painting is the result of an anarchic freedom which glorifies the individual, however feeble he may be, to the detriment of communities—that is to say, of schools.
>
> In schools, which are nothing else but organizations of inventive force, those individuals who are truly worthy of the name absorb the weak. And that is justice, for an absolute production is only a mind equipped with the power of a thousand arms.

Let me be clear: I'm not suggesting that the *Salon of 1846* is at bottom a religious statement any more than that it is essentially a political one. But it is revealing of the sheer scope of Baudelaire's intellectual ambition in that *Salon* that he so deliberately seeks to bridge aesthetics, politics, and, yes, religion, the latter at least rhetorically, metaphorically, in a single overarching argument. (One

can almost see him thinking: What about it, have I out-done Diderot?)

Which brings us to the final section, "On the Heroism of Modern Life," a surprisingly complex few pages that on the face of it have nothing obvious to do with the con-siderations so far canvassed. The argument seems to run: it is true that the great tradition of earlier art has been lost and that a new one is not yet established; but it is important to recognize that all centuries and all peoples have had their own form of beauty, from which it follows that we moderns do too. In greater (Stendhalian) detail:

All forms of beauty, like all possible phenomena, con-tain an element of the eternal and an element of the transitory—of the absolute and of the particular. Ab-solute and eternal beauty does not exist, or rather it is only an abstraction skimmed from the general sur-face of different beauties. The particular element in each manifestation comes from the [passions]: and just as we have our own particular [passions], so we have our own beauty.

Leading to one last autograph burst of precocious genius:

But all the same [that is, despite the tendency of con-temporary artists to depreciate contemporary dress], has not this much-abused garb its own beauty and its native charm? Is it not the necessary garb of our

suffering age, which wears the symbol of a perpet-
ual mourning even upon its thin black shoulders?
Note, too, that the dress-coat and the frock-coat not
only possess their political beauty, which is an ex-
pression of universal equality, but also their poetic
beauty, which is an expression of the public soul—
an immense cortège of undertaker's mutes (mutes
in love, political mutes, bourgeois mutes ...). We are
each of us celebrating some funeral.

Despite what will be his reservations about pictorial
realism, it is tempting to read in these melancholic,
graphically vivid remarks an anticipation of Courbet's
early masterpiece, *A Burial at Ornans* (1850), in which a
slowly winding cortége of rural bourgeois in black out-
fits makes its way toward an open grave in the near fore-
ground of the canvas—not that it is likely that Baude-
laire's imagery influenced the young master of Ornans.
But the coincidence has always been found intriguing,
with good reason.

We are almost at the end of the *Salon*. By way of clos-
ing, Baudelaire contends that the life of contemporary
Paris is rich in "poetic and marvelous subjects," includ-
ing the nude (marked by "modern beauty"—a foretaste
of *Olympia*?), and going on to cite several heroes from
Balzac novels and a play, leading to the final half sen-
tence (at which he has been aiming all along): "and you,
Honoré de Balzac, you the most heroic, the most extraor-
dinary, the most romantic, and the most poetic of all

the characters that you have produced from your womb."
With this climactic apostrophe, the only such moment
in the text, the *Salon of 1846*, having done all it could to
equal or surpass the greatest art criticism in the tradi-
tion, moves to acknowledge and thus to position itself in
relation to the supreme French literary achievement of
the previous decades, Balzac's *Comédie humaine*.

1 For the original *Salon*, I am using the text given in Henri Lemaitre,
 ed., *Curiosités esthétiques, L'Art romantique, et autres oeuvres critiques
 de Baudelaire* (Paris: Garnier, 1962), pp. 97–200. See also the scholarly
 edition, Charles Baudelaire, *Salon de 1846*, ed. David Kelley (Oxford:
 Clarendon Press, 1975).

2 Letter of March 5, 1852, to Narcisse Ancelle; see Baudelaire, *Corre-
 spondance*, ed. Claude Pichois and Jérôme Thélot (Paris: Gallimard,
 2000), p. 69. For a brilliant treatment of Baudelaire in 1848 and its
 aftermath, see T. J. Clark, *The Absolute Bourgeois: Artists and Politics
 in France 1848–1851* (London: Thames & Hudson, 1973; Princeton, NJ:
 Princeton University Press, 1982), pp. 141–177. A basic biography is
 Claude Pichois, *Baudelaire*, trans. Graham Robb (London: H. Ham-
 ilton, 1989).

3 For a fuller presentation of these claims, see Michael Fried, "Painting
 Memories: On the Containment of the Past in Baudelaire and Manet,"
 Critical Inquiry 10 (March 1984), pp. 510–542. See also the response
 by Richard Shiff, "Remembering Impressions," *Critical Inquiry* 12
 (Winter 1986), pp. 439–448, as well as the reply to Shiff by me, "Forget
 It," ibid., pp. 449–452. Recently my account has been taken up and
 discussed by Julien Zanetta, *Baudelaire, la mémoire et les arts* (Paris:
 Garnier, 2019).

4 For the original French, see H. F. Stewart, D.D., *Pascal's Pensées*, with
 an English translation, brief notes, and introduction (London: Rout-
 ledge and Kegal Paul, 1950; Routledge Revivals, 2020), p. 220. On that
 pensée, see Erich Auerbach, "On the Political Theory of Pascal," *Scenes
 from the Drama of European Literature* (New York: Meridian Books,
 1959), pp. 101–129.

You are the majority—in number and intelligence; therefore you are the force—which is justice.

Some are scholars, others ore owners; a glorious day will come when the scholars shall be owners and the owners scholars. Then your power will be complete, and no man will protest against it.

Until that supreme harmony is achieved, it is just that those who are but owners should aspire to become scholars; for knowledge is no less of an enjoyment than ownership.

The government of the city is in your hands, and that is just, for you are the force. But you must also be capable of feeling beauty; for as not one of you today can do without power, so not one of you has the right to do without poetry.

You can live three days without bread—without poetry, never; and those of you who can say the contrary are mistaken; they are out of their minds.

The aristocrats of thought, the distributors of praise and blame, the monopolists of the things of the mind, have told you that you have no right to feel and to enjoy—they are Pharisees.

For you have in your hands the government of a city whose public is the public of the universe, and it is necessary that you should be worthy of that task.

Enjoyment is a science, and the exercise of the five senses calls for a particular initiation which only comes about through goodwill and need.

Very well, you need art.

Art is an infinitely precious good, a draft both refreshing and cheering which restores the stomach and the mind to the natural equilibrium of the ideal.

You understand its function, you gentlemen of the bourgeoisie—whether lawgivers or businessmen—when the seventh or the eighth hour strikes and you bend your tired head toward the embers of your hearth or the cushions of your armchair.

That is the time when a keener desire and more active reverie would refresh you after your daily labors.

But the monopolists have decided to keep the forbidden fruit of knowledge from you, because knowledge is their counter and their shop, and they are infinitely jealous of it. If they had merely denied you the power to create works of art or to understand the processes by which they are created, they would have asserted a truth at which you could not take offense, because public business and trade take up three quarters of your day. And as for your leisure hours, they should be used for enjoyment and pleasure.

But the monopolists have forbidden you even to enjoy, because you do not understand the technique of the arts, as you do those of the law and of business.

And yet it is just that if two-thirds of your time are devoted to knowledge, then the remaining third should be occupied by feeling—and it is by feeling alone that art is to be understood; and it is in this way that the equilibrium of your soul's force will be established.

Truth, for all its multiplicity, is not two-faced; and just as in your politics you have increased both rights and benefits,

so in the arts you have set up a greater and more abundant communion.

You, the bourgeois—be you king, law-giver, or business-man—have founded collections, museums, and galleries. Some of those, which sixteen years ago were only open to the monopolists, have thrown wide their doors to the multitude.

You have combined together, you have formed companies and raised loans in order to realize the idea of the future in all its varied forms—political, industrial, and artistic. In no noble enterprise have you ever left the initiative to the pro-testing and suffering minority,[1] which anyway is the natural enemy of art.

For to allow oneself to be outstripped in art and in politics is to commit suicide; and for a majority to commit suicide is impossible.

And what you have done for France, you have done for other countries too. The Spanish Museum is there to in-crease the volume of general ideas that you ought to pos-sess about art; for you know perfectly well that just as a national museum is a kind of communion by whose gentle influence men's hearts are softened and their wills unbent, so a foreign museum is an international communion where two peoples, observing and studying one another more at their ease, can penetrate one another's mind and fraternize without discussion.

You are the natural friends of the arts, because you are some of you rich men and the other scholars.

When you have given to society your knowledge, your in-dustry, your labor, and your money, you claim back your pay-

ment in enjoyments of the body, the reason, and the imagination. If you recover the amount of enjoyments which is needed to establish the equilibrium of all parts of your being, then you are happy, satisfied, and well-disposed, as society will be satisfied, happy, and well-disposed when it has found its own general and absolute equilibrium.

And so it is to you, the bourgeois, that this book is naturally dedicated; for any book which is not addressed to the majority—in number and intelligence—is a stupid book.

May 1, 1846

I. WHAT IS THE GOOD OF CRITICISM?

What is the good?—A vast and terrible question mark which seizes the critic by the throat from his very first step in the first chapter that he sits down to write.

At once the artist reproaches the critic with being unable to teach anything to the bourgeois, who wants neither to paint nor to write verses—nor even to art itself, since it is from the womb of art that criticism was born.

And yet how many artists today owe to the critics alone their sad little fame! It is there perhaps that the real reproach lies.

You will have seen a Gavarni which shows a painter bending over his canvas; behind him stands a grave, lean, stiff gentleman, in a white cravat holding his latest article in his hand. "If art is noble, criticism is holy."—"Who says that?"—"The critics!"[1] If the artist plays the leading role so easily, it is doubtless because his critic is of a type which we know so well.

Regarding technical means and processes taken from the works themselves,[2] the public and the artist will find nothing to learn here. Things like that are learned in the studio, and the public is only concerned about the result.

I sincerely believe that the best criticism is that which is both amusing and poetic: not a cold, mathematical criticism which, on the pretext of explaining everything, has neither love nor hate, and voluntarily strips itself of every shred of temperament. But, seeing that a fine picture is nature reflected by an artist, the criticism which

I approve will be that picture reflected by an intelligent and sensitive mind. Thus the best account of a picture may well be a sonnet or an elegy.

But this kind of criticism is destined for anthologies and readers of poetry. As for criticism properly so-called, I hope that the philosophers will understand what I am going to say. To be just, that is to say, to justify its existence, criticism should be partial, passionate, and political, that is to say, written from an exclusive point of view, but a point of view that opens up the widest horizons.

To extol line to the detriment of color, or color at the expense of line, is doubtless a point of view, but it is neither very broad nor very just, and it indicts its holder of a great ignorance of individual destinies.

You cannot know in what measure Nature has mingled the taste for line and the taste for color in each mind, nor by what mysterious processes she manipulates that fusion whose result is a picture.

Thus a broader point of view will be an orderly individualism—that is, to require of the artist the quality of *naïveté* and the sincere expression of his temperament, aided by every means which his technique provides.[3] An artist without temperament is not worthy of painting pictures, and—as we are wearied of imitators and, above all, of eclectics—he would do better to enter the service of a painter of temperament, as a humble workman.

I shall demonstrate this in one of my later chapters.

The critic should arm himself from the start with a sure criterion, a criterion drawn from nature, and should

then carry out his duty with passion; for a critic does not cease to be a man, and passion draws similar temperaments together and exalts the reason to fresh heights.

Stendhal has said somewhere: "Painting is nothing but a construction in ethics!"[4] If you will understand the word "ethics" in a more or less liberal sense, you can say as much of all the arts. And as the essence of the arts is always the expression of the beautiful through the feeling, the passion and the dreams of each man—that is to say a variety within a unity, or the various aspects of the absolute—so there is never a moment when criticism is not in contact with metaphysics.

As every age and every people has enjoyed the expression of its own beauty and ethos—and if, by *romanticism*, you are prepared to understand the most recent, the most modern expression of beauty—then, for the reasonable and passionate critic, the great artist will be he who will combine with the condition required above—that is, the quality of *naïveté*—the greatest possible amount of romanticism.

II. WHAT IS ROMANTICISM?

Few people today will want to give a real and positive meaning to this word; and yet will they dare assert that a whole generation would agree to join a battle lasting several years for the sake of a flag which was not also a symbol?

If you think back to the disturbances of those recent times, you will see that if but few romantics have survived, it is because few of them discovered romanticism, though all of them sought it sincerely and honestly.

Some applied themselves only to the choice of subjects; but they had not the temperament for their subjects. Others, still believing in a Catholic society, sought to reflect Catholicism in their works. But to call oneself a romantic and to look systematically at the past is to contradict oneself. Some blasphemed the Greeks and the Romans in the name of romanticism: but you can only make Romans and Greeks into romantics if you are one yourself. Many others have been misled by the idea of truth in art, and local color. Realism had already existed for a long time when that great battle took place, and besides, to compose a tragedy or a picture to the requirements of M. Raoul Rochette is to expose yourself to a flat contradiction from the first comer if he is more learned than M. Raoul Rochette.[1]

Romanticism is precisely situated neither in choice of subjects nor in exact truth, but in a mode of feeling.

They looked for it outside themselves, but it was only to be found within.

For me, romanticism is the most recent, the latest expression of the beautiful.

There are as many kinds of beauty as there are habitual ways of seeking happiness.[2]

This is clearly explained by the philosophy of progress; thus, as there have been as many ideals as there have been ways in which the peoples of the earth have understood ethics, love, religion, etc., so romanticism will not consist in a perfect execution, but in a conception analogous to the ethical disposition of the age.

It is because some have located it in a perfection of technique that we have had the *rococo* of romanticism, without question the most intolerable of all forms.

Thus it is necessary, first and foremost, to get to know those aspects of nature and those human situations which the artists of the past have disdained or have not known.

To say the word "romanticism" is to say modern art—that is, intimacy, spirituality, color, aspiration toward the infinite, expressed by every means available to the arts.

Thence it follows that there is an obvious contradiction between romanticism and the works of its principal adherents.

Does it surprise you that color should play such a very important part in modern art? Romanticism is a child of the North, and the North is all for color: dreams and fairy-tales are born of the mist. England—that home of fanatical colorists—Flanders, and half of France are all plunged in fog; Venice herself lies steeped in her lagoons. As for the painters of Spain, they are painters of contrast rather than colorists.

The South, in return, is all for nature; for there nature is so beautiful and bright that nothing is left for man to desire, and he can find nothing more beautiful to invent than what he sees. There art belongs to the open air: but several hundred leagues to the north you will find the deep dreams of the studio and the gaze of the fancy lost in horizons of gray.

The South is as brutal and positive as a sculptor even in his most delicate compositions; the North, suffering and restless, seeks comfort with the imagination, and if it turns to sculpture, it will more often be picturesque than classical.

Raphael, for all his purity, is but an earthly spirit ceaselessly investigating the solid; but that scoundrel Rembrandt is a sturdy idealist who makes us dream and guess at what lies beyond. The first composes creatures in a pristine and virginal state—Adam and Eve; but the second shakes his rags before our eyes and tells us of human sufferings.

And yet Rembrandt is not a pure colorist, but a harmonizer. How novel then would be the effect, and how matchless his romanticism, if a powerful colorist could realize our dearest dreams and feelings for us in a color appropriate to their subjects!

But before passing on to an examination of the man who up to the present is the most worthy representative of romanticism, I should like to give you a series of reflections on color, which will not be without use for the complete understanding of this little book.

III. ON COLOR

Let us suppose a beautiful expanse of nature, where there is full license for everything to be as green, red, dusty, or iridescent as it wishes; where all things, variously colored in accordance with their molecular structure, suffer continual alteration through the transposition of shadow and light; where the workings of latent heat allow no rest, but everything is in a state of perpetual vibration which causes lines to tremble and fulfills the law of eternal and universal movement. An immensity which is sometimes blue, and often green, extends to the confines of the sky; it is the sea. The trees are green, the grass and the moss are green; the tree-trunks are snaked with green, and the unripe stalks are green; green is nature's ground-bass, because green marries easily with all the other colors.[1] What strikes me first of all is that everywhere—whether it be poppies in the grass, pimpernels, parrots, etc.—red sings the glory of green; black (where it exists—a solitary and insignificant cipher) intercedes on behalf of blue or red. The blue—that is, the sky—is cut across with airy flecks of white or with gray masses, which pleasantly temper its bleak crudeness; and as the vaporous atmosphere of the season—winter or summer—bathes, softens, or engulfs the contours, nature seems like a spinning-top which revolves so rapidly that it appears gray, although it embraces within itself the whole gamut of colors.

The sap rises, and as the principles mix, there is a flowering of *mixed tones*; trees, rocks, and granite boul-

ders gaze at themselves in the water and cast their *reflections* upon them; each transparent object picks up light and color as it passes from nearby or afar. According as the daystar alters its position, tones change their values, but, always respecting their natural sympathies and antipathies, they continue to live in harmony by making reciprocal concessions. Shadows slowly shift, and colors are put to flight before them, or extinguished altogether, according as the light, itself shifting, may wish to bring fresh ones to life. Some colors cast back their reflections upon one another, and by modifying their own qualities with a *glaze* of transparent, borrowed qualities, they combine and recombine in an infinite series of melodious marriages which are thus made more easy for them. When the great brazier of the sun dips beneath the waters, fanfares of red surge forth on all sides; a harmony of blood flares up at the horizon, and green turns richly crimson. Soon vast blue shadows are rhythmically sweeping before them the host of orange and rose-pink tones which are like a faint and distant echo of the light. This great symphony of today, which is an eternal variation of the symphony of yesterday, this succession of melodies whose variety ever issues from the infinite, this complex hymn is called *color*.

In color are to be found harmony, melody, and counterpoint.

If you will examine the detail within the detail in an object of medium dimensions—for example, a woman's hand, rosy, slender, with skin of the finest—you will see

that there is perfect harmony between the green of the strong veins with which it is ridged and the ruby tints which mark the knuckles; pink nails stand out against the topmost joints, which are characterized by several gray and brown tones. As for the palm of the hand, the lifelines, which are pinker and more wine-colored, are separated one from another by the system of green or blue veins which run across them. A study of the same object, carried out with a lens, will afford, within however small an area, a perfect harmony of gray, blue, brown, green, orange, and white tones, warmed by a touch of yellow—a harmony which, when combined with shadows, produces the colorist's type of modeling, which is essentially different from that of the draftsman, whose difficulties more or less boil down to the copying of a plaster cast.

Color is thus the accord of two tones. Warmth and coldness of tone, in whose opposition all theory resides, cannot be defined in an absolute manner; they only exist in a relative sense.

The lens is the colorist's eye.

I do not wish to conclude from all this that a colorist should proceed by a minute study of the tones commingled in a very limited space. For if you admit that every molecule is endowed with its own particular tone, it would follow that matter should be infinitely divisible; and besides, as art is nothing but an abstraction and a sacrifice of detail to the whole, it is important to concern oneself above all with *masses*. I merely wished to prove

that if the case were possible, any number of tones, so long as they were logically juxtaposed, would fuse naturally in accordance with the law which governs them.

Chemical affinities are the grounds whereby Nature cannot make mistakes in the arrangement of her tones; for with Nature, form and color are one.

No more can the true colorist make mistakes; everything is allowed him, because from birth he knows the whole scale of tones, the force of tone, the results of mixtures, and the whole science of counterpoint, and thus he can produce a harmony of twenty different reds.

This is so true that if an anti-colorist landowner took it into his head to repaint his property in some ridiculous manner and in a system of cacophonous colors, the thick and transparent varnish of the atmosphere and the learned eye of a Veronese between them would put the whole thing right and would produce a satisfying ensemble on canvas—conventional, no doubt, but logical.

This explains how a colorist can be paradoxical in his way of expressing color, and how the study of nature often leads to a result quite different from nature.

The air plays such an important part in the theory of color that if a landscape painter were to paint the leaves of a tree just as he sees them, he would secure a false tone, considering that there is a much smaller expanse of air between the spectator and the picture than between the spectator and nature.

Falsifications are continually necessary, even in order to achieve a *trompe l'oeil*.

Harmony is the basis of the theory of color.

Melody is unity within color, or overall color.

Melody calls for a cadence; it is a whole, in which every effect contributes to the general effect.

Thus melody leaves a deep and lasting impression on the mind.

Most of our young colorists lack melody.

The right way to know if a picture is melodious is to look at it from far enough away to make it impossible to understand its subject or to distinguish its lines. If it is melodious, it already has a meaning and has already taken its place in your store of memories.

Style and feeling in color come from choice, and choice comes from temperament.

Colors can be gay and playful, playful and sad, rich and playful, gay, rich, and sad, commonplace and original.

Thus Veronese's color is tranquil and gay. Delacroix's color is often plaintive, and that of M. Catlin is often terrible.

For a long time I lived opposite a drinking-shop which was crudely striped in red and green; it afforded my eyes a delicious pain.

I do not know if any *analogist* has ever established a complete scale of colors and feelings, but I remember a passage in Hoffmann which expresses my idea perfectly and which will appeal to all those who sincerely love nature: "It is not only in dreams, or in that mild delirium which precedes sleep, but it is even awakened when I

hear music—that perception of an analogy and an intimate connection between colors, sounds, and perfumes. It seems to me that all these things were created by one and the same ray of light, and that their combination must result in a wonderful concert of harmony. The smell of red and brown marigolds above all produces a magical effect on my being. It makes me fall into a deep reverie, in which I seem to hear the solemn, deep tones of the oboe in the distance."[2]

It is often asked if the same man can be at once a great colorist and a great draftsman.

Yes and no; for there are different kinds of drawing.

The quality of pure draftsmanship consists above all in precision, and this precision excludes *touch*; but there are such things as happy touches, and the colorist who undertakes to express nature through color would often lose more by suppressing his happy touches than by studying a greater austerity of drawing.

Certainly color does not exclude great draftsmanship—that of Veronese, for example, which proceeds above all by ensemble and by mass; but it does exclude the meticulous drawing of detail, the contour of the tiny fragment, where touch will always eat away line.

The love of air and the choice of subjects in movement call for the employment of flowing and fused lines.

Exclusive draftsmen act in accordance with an inverse procedure which is yet analogous. With their eyes fixed upon tracking and surprising their line in its most secret convolutions, they have no time to see air and

light—that is to say, the effects of these things—and they even compel themselves *not* to see them, in order to avoid offending the dogma of their school.

It is thus possible to be at once a colorist and a draftsman, but only in a certain sense. Just as a draftsman can be a colorist in his broad masses, so a colorist can be a draftsman by means of a total logic in his linear ensemble; but one of these qualities always engulfs the detail of the other.

The draftsmanship of colorists is like that of nature; their figures are naturally bounded by a harmonious collision of colored masses.

Pure draftsmen are philosophers and dialecticians.

Colorists are epic poets.

Romanticism and color lead me straight to Eugène Dela-
croix. I do not know if he is proud of his title of "roman-
tic," but his place is here, because a long time ago—from
his very first work, in fact—the majority of the public
placed him at the head of the *modern* school.

As I enter upon this part of my work, my heart is full
of a serene joy, and I am purposely selecting my new-
est pens, so great is my desire to be clear and limpid, so
happy do I feel to be addressing my dearest and most
sympathetic subject. But in order to make the conclu-
sions of this chapter properly intelligible, I must first
go back some little distance in the history of this pe-
riod, and place before the eyes of the public certain doc-
uments of the case which have already been cited by
earlier critics and historians, but which are necessary
to complete my demonstration. Nevertheless, I do not
think that true admirers of Eugène Delacroix will feel
anything but a keen pleasure in rereading an extract
from the *Constitutionnel* of 1822, taken from the Salon
of M. Thiers,[1] journalist.

> In my opinion no picture is a clearer revelation of
> future greatness than M. Delacroix's *Le Dante et Vir-
> gile aux Enfers*.[2] Here above all you can recognize the
> spurt of talent, that burst of dawning mastery which
> revives our hopes, already a trifle dashed by the too
> moderate worth of all the rest.

Dante and Virgil are being ferried across the infernal stream by Charon; they cleave their way with difficulty through the mob which swarms round the barque in order to clamber aboard. Dante, pictured alive, bears the dreadful taint of the place: Virgil, crowned with gloomy laurel, wears the colors of death. The hapless throng, doomed eternally to crave the opposite bank, are clinging to the boat: one is clutching at it in vain, and, thrown backward by his precipitate effort, plunges once more into the waters; another has hold, and is kicking back those who, like himself, are struggling to get on board; two others are gripping at the elusive timber with their teeth. There you have all the egoism of misery, the despair of Hell. In a subject which borders so closely on exaggeration, you will yet find a severity of taste, a propriety of setting, so to say, which enhances the design, though stern judges—*in this case ill-advised*—might perhaps criticize it for a lack of nobility. It is painted with a broad, firm brush, and its color is simple and vigorous, if a trifle raw.

Apart from that poetic imagination which is common both to painter and writer, the author of this picture has another, *artistic* imagination, which one might almost call "the graphic imagination,"[3] and which is quite different from the first. He throws his figures on to the canvas, he groups and bends them at will, with the boldness of Michelangelo and the abundance of Rubens. Some strange recollection of

the great masters seized hold of me at the sight of this picture; once more I found that power—wild, ardent, but natural—which yields without effort to its own impulse....

I do not believe that I am mistaken when I say that M. Delacroix has been given genius. Let him advance with assurance, let him devote himself to immense tasks, an indispensable condition of talent; and let him take still further confidence when I say that the opinion which I am expressing here is shared by one of the great masters of the school.[4]

A. T... rs

These enthusiastic paragraphs are truly staggering, as much for their precocity as for their boldness. If, as is to be presumed, the editor of the journal had pretensions himself as a connoisseur of painting, the young Thiers must have struck him as a trifle mad.

To obtain a proper idea of the profound confusion into which the picture of Dante and Virgil must have thrown contemporary minds—of the amazement, the dumbfoundedness, the rage, the shouts of praise and of abuse, the enthusiasm, and the peals of offensive laughter which beset this fine picture (a true signal of revolution)—you must remember that in the studio of M. Guérin (a man of great worth, but a despot and absolutist, like his master David) there was only a small group of pariahs who devoted themselves in secret to the old masters and who dared shyly to conspire beneath the

wing of Raphael and Michelangelo. There was as yet no question of Rubens.

M. Guérin, who was harsh and severe toward his young pupil, only looked at the picture because of the clamor that raged around it.

Géricault, who was back from Italy (where he was said to have renounced several of his almost original qualities before the great frescoes of Rome and Florence) complimented the new and still bashful painter so warmly that he was almost overcome.[5]

It was in front of this painting, or, some time afterward, in front of the *Pestiférés de Scio*,[6] that Gérard himself, who, as it seems, was more a wit than a painter, cried, "A painter has just been revealed to us, but he is a man who runs along the rooftops!"—To run along the rooftops you need a firm step and an eye illumined by an interior light.

Let glory and justice be accorded to MM. Thiers and Gérard!

It is doubtless a lengthy interval that separates the *Dante and Virgil* from the paintings in the Palais Bourbon;[7] but the biography of Eugène Delacroix is poor in incident. For a man like this, endowed with such courage and such passion, the most interesting struggles are those which he has to maintain against himself; horizons need not be vast for battles to be important, and the most curious events and revolutions take place beneath the firmament of the skull, in the close and mysterious laboratory of the brain.

Now that the man had been duly revealed and was continuing to reveal himself more and more (in the allegorical picture *La Grèce*,[8] *Sardanapalus*,[9] *La Libertè*,[10] etc.), and now that the contagion of the new gospel was spreading from day to day, even academic disdain found itself forced to take this new genius into account. One fine day M. Sosthène de La Rochefoucauld, then *Directeur des Beaux-Arts*, sent for Eugène Delacroix, and, after lavishing compliments upon him, told him that it was vexing that a man of so rich an imagination and so fine a talent, a man, moreover, to whom the government was favorably disposed, should not be prepared to add a little water to his wine; he asked him once and for all if it would not be possible for him to modify his manner. Eugène Delacroix, vastly surprised at this quaint condition and these ministerial counsels, replied with almost a parody of rage that evidently if he painted thus, it was because he had to and because he could not paint otherwise. He fell into complete disgrace and was cut off from any kind of official work for seven years. He had to wait for 1830. Meanwhile M. Thiers had written a new and very lofty article in *Le Globe*.[11]

A journey to Morocco[12] seems to have left a deep impression on his mind; there he could study at leisure both man and woman in their independence and native originality of movement, and could comprehend antique beauty in the sight of a race pure of all base-breeding and adorned with health and the free development of its muscles. The composition of *The Women*

of Algiers[13] and a mass of sketches probably date from this period.

Up to the present, Eugène Delacroix has met with injustice. Criticism, for him, has been bitter and ignorant; with one or two noble exceptions, even the praises of his admirers must often have seemed offensive to him. Generally speaking, and for most people, to mention Eugène Delacroix is to throw into their minds goodness knows what vague ideas of ill-directed fire, of turbulence, of hazardous inspiration, of chaos, even; and for those gentlemen who form the majority of the public, pure chance, that loyal and obliging servant of genius, plays an important part in his happiest compositions. In that unhappy period of revolution of which I was speaking a moment ago, and whose numerous errors I have recorded, people used often to compare Eugène Delacroix to Victor Hugo. They had their romantic poet; they needed their painter. This necessity of going to any length to find counterparts and analogues in the different arts often results in strange blunders; and this one proves once again how little people knew what they were about. Without any doubt the comparison must have seemed a painful one to Eugène Delacroix, if not to both of them; for if my definition of romanticism (intimacy, spirituality, and the rest) places Delacroix at its head, it naturally excludes M. Victor Hugo. The parallel has endured in the banal realm of accepted ideas, and these two preconceptions still encumber many feeble brains. Let us be done with these rhetorical ineptitudes once and for all. I beg

all those who have felt the need to create some kind of aesthetic for their own use and to deduce causes from their results, to make a careful comparison between the productions of these two artists.

M. Victor Hugo, whose nobility and majesty I certainly have no wish to belittle, is a workman far more adroit than inventive, a laborer much more correct than *creative*. Delacroix is sometimes clumsy, but he is essentially creative. In all his pictures, both lyric and dramatic, M. Victor Hugo lets one see a system of uniform alignment and contrasts. With him even eccentricity takes symmetrical forms. He is in complete possession of, and coldly employs, all the modulations of rhyme, all the resources of antithesis, and all the tricks of apposition. He is a composer of the decadence or transition, who handles his tools with a truly admirable and curious dexterity. M. Hugo was by nature an academician even before he was born, and if we were still living in the time of fabulous marvels, I would be prepared to believe that often, as he passed before their wrathful sanctuary, the green lions of the Institut would murmur to him in prophetic tones, "Thou shalt enter these portals."

For Delacroix justice is more sluggish. His works, on the contrary, are poems—and great poems, *naïvely*[14] conceived and executed with the usual insolence of genius. In the works of the former there is nothing left to guess at, for he takes so much pleasure in exhibiting his skill that he omits not one blade of grass nor even the reflection of a street lamp. The latter in his work throws

open immense vistas to the most adventurous imaginations. The first enjoys a certain calmness, let us rather say a certain detached egoism, which causes an unusual coldness and moderation to hover above his poetry—qualities which the dogged and melancholy passion of the second, at grips with the obstinacies of his craft, does not always permit him to retain. One starts with detail, the other with an intimate understanding of his subject; from which it follows that one only captures the skin, while the other tears out the entrails. Too earth-bound, too attentive to the superficies of nature, M. Victor Hugo has become a painter in poetry; Delacroix, always respectful of his ideal, is often, without knowing it, a poet in painting.

As for the second preconception, the preconception of pure chance, it has no more substance than the first. Nothing is sillier or more impertinent than to talk to a great artist, and one as learned and as thoughtful as Delacroix, about the obligations which he may owe to the god of chance. It quite simply makes one shrug one's shoulders in pity. There is no pure chance in art, any more than in mechanics. A happy invention is the simple consequence of a sound train of reasoning whose intermediate deductions one may perhaps have skipped, just as a fault is the consequence of a faulty principle. A picture is a machine, all of whose systems of construction are intelligible to the practiced eye; in which everything justifies its existence, if the picture is a good one; where one tone is always planned to make the most of

another; and where an occasional fault in drawing is sometimes necessary, so as to avoid sacrificing something more important.

This intervention of chance in the business of Delacroix's painting is all the more improbable since he is one of those rare beings who remain original after having drunk deep of all the true wells, and whose indomitable individuality has borne and shaken off the yokes of all the great masters in turn. Not a few of you would be quite astonished to see one of his studies after Raphael—patient and laborious masterpieces of imitation; and few people today remember his lithographs after medals and engraved gems.[15]

Here are a few lines from Heinrich Heine which explain Delacroix's method rather well—a method which, like that of all robustly framed beings, is the result of his temperament:

In artistic matters, I am a supernaturalist. I believe that the artist cannot find all his forms in nature, but that the most remarkable are revealed to him in his soul, like the innate symbology of innate ideas, and at the same instant. A modern professor of aesthetics, the author of *Recherches sur l'Italie*,[16] has tried to restore to honor the old principle of the *imitation of nature*, and to maintain that the plastic artist should find all his forms in nature. The professor, in thus setting forth his ultimate principle of the plastic arts, had only forgotten one of those arts, but one of the

most fundamental—I mean architecture. A belated attempt has now been made to trace back the forms of architecture to the leafy branches of the forest and the rocks of the grotto; and yet these forms were nowhere to be found in external nature, but rather in the soul of man.[17]

Now this is the principle from which Delacroix sets out—that a picture should first and foremost reproduce the intimate thought of the artist, who dominates the model as the creator dominates his creation; and from this principle there emerges a second which seems at first sight to contradict it—namely, that the artist must be meticulously careful concerning his material means of execution. He professes a fanatical regard for the cleanliness of his tools and the preparation of the elements of his work. In fact, since painting is an art of deep ratiocination, and one that demands an immediate contention between a host of different qualities, it is important that the hand should encounter the least possible number of obstacles when it gets down to business, and that it should accomplish the divine orders of the brain with a slavish alacrity; otherwise the ideal will escape.

The process of conception of this great artist is no less slow, serious, and conscientious than his execution is nimble. This moreover is a quality which he shares with the painter whom public opinion has set at the opposite pole from him—I mean M. Ingres. But travail is by no means the same thing as childbirth, and these great

princes of painting, though endowed with a seeming in-
dolence, exhibit a marvelous agility in covering a canvas.
St. Symphorian[18] was entirely repainted several times, and
at the outset it contained far fewer figures.

Nature, for Eugène Delacroix, is a vast dictionary
whose leaves he turns and consults with a sure and
searching eye; and his painting which issues above all
from the memory, speaks above all to the memory. The
effect produced upon the spectator's soul is analogous to
the artist's means. A picture by Delacroix—*Dante and Vir-
gil*, for example—always leaves a deep impression whose
intensity increases with distance. Ceaselessly sacrific-
ing detail to whole, and hesitating to impair the vital-
ity of his thought by the drudgery of a neater and more
calligraphic execution, he rejoices in the full use of an
inalienable originality, which is his searching intimacy
with the subject.

The employment of a dominant note can only right-
fully take place at the expense of the rest. An excessive
taste makes sacrifices necessary, and masterpieces are
never anything but varied extracts from nature. That is
the reason why it is necessary to submit to the conse-
quences of a grand passion (whatever it may be), to accept
the destiny of a talent, and not to cry and bargain with
genius. This is a thing never dreamed of by those people
who have jeered so much at Delacroix's draftsmanship—
particularly the sculptors, men more partial and pur-
blind than they have a right to be, whose judgment is
worth no more than half that of an architect, at the most.

Sculpture, to which color is impossible and movement difficult, has nothing to discuss with an artist whose chief preoccupations are movement, color, and atmosphere. These three elements necessarily demand a somewhat undecided contour, light and floating lines, and boldness of touch. Delacroix is the only artist today whose originality has not been invaded by the tyrannical system of straight lines; his figures are always restless and his draperies fluttering. From Delacroix's point of view the line does not exist; for, however tenuous it may be, a teasing geometrician may always suppose it thick enough to contain a thousand others: and for colorists, who seek to imitate the eternal throbbings of nature, lines are never anything else but the intimate fusion of two colors, as in the rainbow.

Moreover there are several kinds of drawings, as there are of color: the exact or silly, the physiognomic, and the imaginative.

The first is negative, incorrect by sheer force of reality, natural but absurd; the second is a naturalistic, but idealized draftsmanship—the draftsmanship of a genius who knows how to choose, arrange, correct, rebuke, and guess at nature; lastly the third, which is the noblest and strangest, and can afford to neglect nature—it realizes *another* nature, analogous to the mind and the temperament of the artist.

Physiognomic drawing is generally the domain of the fanatical, like M. Ingres; creative drawing is the privilege of genius.[19]

The great quality of the drawing of supreme artists is truth of movement; and Delacroix never violates this natural law.

But let us pass on to an examination of still more general qualities. Now one of the principal characteristics of the great painter is his universality. Take an epic poet, Homer or Dante, for example: he can write an idyll, a narrative, a speech, a description, an ode, etc., all equally well.

In the same way, if Rubens paints fruit, he will paint finer fruit than any specialist that you care to name.

Eugène Delacroix is universal. He has painted genre pictures full of intimacy, and historical pictures full of grandeur. He alone, perhaps, in our unbelieving age has conceived religious paintings which were neither empty and cold, like competition works, nor pedantic, mystical, or neo-Christian, like the works of all those philosophers of art who make religion into an archaistic science, and who believe that not until they have made themselves masters of the traditions and symbology of the early church, can they strike and sound the chords of religion.

This is easy to understand if you are prepared to consider that Delacroix, like all the great masters, is an admirable mixture of science—that is to say, he is a complete painter—and of *naïveté*—that is to say, he is a complete man. Go to St. Louis au Marais[20] and look at his *Pietà*, in which the majestic Queen of Sorrows is holding the body of her dead Son on her knees, with her two arms extended horizontally in an access of despair, a

mother's paroxysm of grief. One of the two figures, who is supporting and soothing her anguish, is sobbing like the most pitiful characters in his *Hamlet*—a work with which, moreover, this painting has no little affinity. Of the two holy women, the first, still decked with jewels and tokens of luxury, is crouching convulsively on the ground; the other, fair and golden-haired, sinks more feebly beneath the enormous weight of her despair.

The group is spread out and disposed entirely against a background of a dark, uniform green which suggests a tempest-ridden sea no less than massed boulders. This background is fantastic in its simplicity, for, like Michelangelo, Eugène Delacroix seems to have suppressed the accessories in order not to damage the clarity of his idea. This masterpiece leaves a deep furrow of melancholy upon the mind. But this was not the first he that he had tackled religious subjects. His *Agony in the Garden*[21] and his *St. Sebastian*[22] had already testified to the seriousness and deep sincerity with which he can stamp them.

But to explain what I declared a moment ago—that only Delacroix knows how to paint religious subjects— I would have the spectator note that if his most interesting pictures are nearly always those whose subjects he chooses himself—namely, subjects of fantasy— nevertheless the grave sadness of his talent is perfectly suited to our religion which is itself profoundly sad—a religion of universal anguish, and one which, because of its very catholicity, grants full liberty to the individual and

asks no better than to be celebrated in each man's own language—so long as he knows anguish and is a painter.

I remember a friend of mine—a lad of some merit, too, and an already fashionable colorist; one of those precocious young men who give promise all their lives, and who is far more academic than he himself believes—I remember him calling this "a cannibal's painting."

It is perfectly true that our young friend will look in vain among the niceties of a loaded palette, or in the dictionary of rules, for a blood-soaked and savage desolation such as this, which is only just offset by the somber green of hope.

This terrible hymn to anguish affected his classical imagination in just the same way as the formidable wines of Anjou, Auvergne, or the Rhine affect a stomach which is used to the pale violets of Médoc.

So much for universality of feeling—and now for universality of knowledge!

It is a long time since our painters *unlearned*, so to speak, the genre called "decoration." The *Hemicycle*[23] at the Beaux-Arts is a puerile, clumsy work whose intentions contradict one another; it is hardly more than a collection of historical portraits. The *Plafond d'Homère*[24] is a fine picture which makes a bad ceiling. Most of the chapels executed in recent times and distributed among the pupils of Ingres were done according to the methods of the Italian primitives—that is, they aim at achieving unity by the suppression of effects of light and by a vast system of softened colorings. This method, which

is doubtless more reasonable, nevertheless evades the difficulties. Under Louis XIV, XV, and XVI, painters produced decorations of dazzling brilliance, but they lacked unity in color and composition.

Eugène Delacroix had decorations to paint, and he solved the great problem. He discovered pictorial unity without doing hurt to his trade as a colorist.

We have the Palais Bourbon[25] to bear witness to this extraordinary *tour de force*. There the light is dispensed economically, and it spreads evenly across all the figures, without tyrannically catching the eye.

The circular ceiling in the library of the Luxembourg[26] is a still more astonishing work, in which the painter has arrived not only at an even blander and more unified effect, while suppressing nothing of the qualities of color and light which are the characteristic feature of all his pictures—but he has gone further and revealed himself in an altogether new guise: Delacroix the landscape painter!

Instead of painting Apollo and the Muses, the invariable decoration for a library, Eugène Delacroix has yielded to his irresistible taste for Dante, whom Shakespeare alone, perhaps, can challenge in his mind, and he has chosen the passage where Dante and Virgil meet with the principal poets of antiquity in a mysterious place:

> We ceased not to go, though he was speaking; but passed the wood meanwhile, the wood, I say, of crowded spirits. Our way was not yet far since my

slumber, when I saw a fire which conquered a hemi-sphere of the darkness. We were still a little distant from it; yet not so distant that I did not in part discern what honorable people occupied that place.

"O thou that honorest every science and art; who are these, who have such honor that it separates them from the manner of the rest?"

And he to me: "The honored name, which glori-fies them in that life of thine, gains favor in Heaven which thus advances them."

Meanwhile a voice was heard by me: "Honor the great Poet! His shade returns that was departed."

After the voice had paused and was silent, I saw four great shadows come to us; they had an aspect neither sad nor joyful.

The good Master began to speak: "Mark him with that sword in hand, who comes before the three as their lord: that is Homer, the sovereign poet; the next who comes is Horace the satirist; Ovid is the third, and the last is Lucan. Because each agrees with me in the name which the one voice sounded, they do me honor; and therein they do well."

Thus I saw assembled the goodly school of that lord of highest song, who like an eagle soars above the rest. After they had talked a space together, they turned to me with a sign of salutation; and my Master smiled thereat. And greatly more besides they hon-ored me; for they made me of their number, so that I was a sixth amid such intelligences.[27]

I shall not pay Eugène Delacroix the insult of an exaggerated panegyric for having so successfully mastered the concavity of his canvas, or for having placed his figures upright upon it. His talent is above these things. I am concentrating above all upon the *spirit* of this painting. It is impossible to express in prose all the blessed calm which it breathes, and the deep harmony which imbues its atmosphere. It makes you think of the most luxuriant pages of *Télémanque*, and brings to life all the memories which the mind has ever gathered from tales of Elysium. From the point of view at which I took up my position a short while ago, the landscape, which is nevertheless no more than an accessory—such is the universality of the great masters!—is a thing of the greatest importance. This circular landscape, which embraces an enormous area, is painted with the assurance of a history painter, and with the delicacy and love of a painter of landscape. Clumps of laurel and considerable patches of shade dissect it harmoniously; pools of gentle, uniform sunlight slumber on the greensward; mountains, blue or forest-girt, form a perfect horizon *for the eyes' pleasure*.[28] The sky is blue and white—an amazing thing with Delacroix; the clouds, which are spun and drawn out in different directions, like a piece of gauze being rent, are of a wonderful airiness; and the deep and luminous vault of the sky recedes to a prodigious height. Even Bonington's watercolors are less transparent.

This masterpiece, which, in my opinion, is superior to the finest of Veronese, needs a great tranquility of

mind and a very gentle light to be properly compre-
hended. Unfortunately the brilliant daylight which will
burst through the great window of the facade, as soon as
it is cleared of its tarpaulins and scaffolding, will make
this task more difficult.

Delacroix's pictures this year are *The Abduction of
Rebecca* taken from *Ivanhoe*, the *Farewell of Romeo and
Juliet*, *Marguerite in Church*, and *A Lion* in watercolor.

The admirable thing about *The Abduction of Rebecca*[29]
is the perfect ordering of its colors, which are intense,
close-packed, serried, and logical; the result of this is
a thrilling effect. With almost all painters who are not
colorists, you will always be noticing vacuums, that is to
say great holes, produced by tones which are below the
level of the rest, so to speak. Delacroix's painting is like
nature; it has a horror of a vacuum.

Romeo and Juliet are shown on the balcony, in the
morning's cold radiance, holding one another devoutly
clasped by the waist. In the violence of this farewell em-
brace, Juliet, with her hands laid on the shoulders of
her lover, is throwing back her head as though to draw
breath, or in a movement of pride and joyful passion.
This unwonted attitude—for almost all painters glue
their lovers' lips together—is nevertheless perfectly nat-
ural; this vigorous movement of the neck is typical of
dogs and cats in the thrill of a caress. The scene, with the
romantic landscape which completes it, is enveloped in
the purplish mists of the dawn.

The general success which this picture has achieved,

and the interest which it inspires, only goes to show what I have already said elsewhere, that Delacroix is *popular*, whatever the painters may say; and that it will be enough not to keep the public away from his works for him to be as much so as inferior painters are.

Marguerite in Church[30] belongs to that already numerous class of charming genre pictures, by which Delacroix seems to be wanting to explain his lithographs,[31] which have been so bitterly criticized.

The watercolor *Lion* has a special merit for me, quite apart from its beauty of drawing and attitude; this is because it is painted with a great simplicity. Watercolor is restricted here to its own modest role; it makes no attempt to rival oil paint in stature.

To complete this analysis, it only remains for me to note one last quality in Delacroix—but the most remarkable quality of all, and that which makes him the true painter of the nineteenth century; it is the unique and persistent melancholy with which all his works are imbued, and which is revealed in his choice of subject, in the expression of his faces, in gesture and in style of color. Delacroix has a fondness for Dante and Shakespeare, two other great painters of human anguish: he knows them through and through, and is able to translate them freely. As you look through the succession of his pictures, you might think that you were assisting at the celebration of some dolorous mystery: *Dante and Virgil*, *The Massacre at Chios*, *Sardanapalus*, *Christ in the Garden of Olives*, *St. Sebastian*, *Medea*,[32] *The Ship-*

wreck of Don Juan,[33] and the *Hamlet*,[34] which was so much mocked at and so misunderstood. In several of them, by some strange and recurring accident, you will find one figure which is more stricken, more crushed than the others; a figure in which all the surrounding anguish is epitomized—for example, the kneeling woman, with her hair cast down, in the foreground of the *Crusaders at Constantinople*,[35] or the old woman, so wrinkled and forlorn, in *The Massacre at Chios*. This aura of melancholy surrounds even the *Women of Algiers*,[36] that most engaging and showy of his pictures. That little poem of an interior, all silence and repose, and crammed with rich stuffs and knickknacks of the toilet, seems somehow to exhale the heady scent of a bordello, which quickly enough guides our thoughts toward the fathomless limbo of sadness. Generally speaking he does not paint pretty women— not at any rate from the point of view of the fashionable world. Almost all of them are sick, and gleaming with a sort of interior beauty. He expresses physical force not by bulk of muscle, but by nervous tension. He is unrivaled at expressing not merely suffering, but above all *moral* suffering—and here lies the prodigious mystery of his painting! This lofty and serious melancholy of his shines with a gloomy brilliance, even in his color, which is broad, simple, and abundant in harmonious masses, like that of all the great colorists; and yet it is as plaintive and deep-toned as a melody by Weber.[37]

Each one of the old masters has his kingdom, his prerogative, which he is often constrained to share with

illustrious rivals. Thus Raphael has form, Rubens and Veronese color, Rubens and Michelangelo the "graphic imagination." There remained one province of the empire in which Rembrandt alone had carried out a few raids; I mean drama, natural and living drama, the drama of terror and melancholy, expressed often through color, but always through gesture.

In the matter of sublime gestures, Delacroix's only rivals are outside his art. I know of scarcely any others but Frédérick Lemaître[38] and Macready.[39]

It is because of this entirely modern and novel quality that Delacroix is the latest expression of progress in art. Heir to the great tradition—that is, to breadth, nobility, and magnificence in composition—and a worthy successor of the old masters, he has even surpassed them in his command of anguish, passion, and gesture! It is really this fact that establishes the importance of his greatness. Suppose, indeed, that the baggage of one of the illustrious departed were to go astray; he will almost always have his counterpart, who will be able to explain him and disclose his secret to the historian's scrutiny. But take away Delacroix, and the great chain of history is broken and slips to the ground.

In an article which must seem more like a prophesy than a critique, what is the object of isolating faults of detail and microscopic blemishes? The whole is so fine that I have not the heart. Besides it is such an easy thing to do, and so many others have done it! Is it not a pleasant change to view people from their good side? M. Dela-

croix's defects are at times so obvious that they strike the least trained eye. You have only to open at random the first paper that comes your way, and you will find that they have long followed the opposite method from mine, in persistently not seeing the glorious qualities which constitute his originality. Need I remind you that great geniuses never make mistakes by halves, and that they have the privilege of enormity in every direction?

Among Delacroix's pupils there are some who have happily appropriated whatever elements of his talent could be captured—that is, certain parts of his method—and who have already earned themselves something of a reputation. Nevertheless their color has, generally speaking, this flaw—that it scarcely aims above picturesqueness and "effect"; the ideal is in no sense their domain, although they readily dispense with nature, without having earned the right to do so by dint of their master's intrepid studies.

This year we must regret the absence of M. Planet, whose *Sainte Thérèse* attracted the eyes of the of the connoisseurs at the last Salon—and of M. Riesener, who has often given us broadly colored pictures, and by whom you can see some good ceilings at the Chambre des Pairs—and see them with pleasure, too, in spite of the terrible proximity of Delacroix.

M. Léger Chérelle has sent *Le Martyre de Sainte Irène*.[40] The composition consists of a single figure and a pike, which makes a somewhat unpleasant effect. Nevertheless

the color and the modeling of the torso are generally good. But I rather think that M. Léger Chérelle had already shown the public this picture before, with some minor variations.

A somewhat surprising feature of *La Mort de Cléopâtre*,[41] by M. Lassale-Bordes, is that the artist does not seem to be uniquely preoccupied with color; and this is perhaps a merit. Its tints are, so to speak, equivocal, and this sourness of taste is not without its charms.

Cleopatra is dying, on her throne, while Octavius's envoy stoops forward to gaze at her. One of her handmaidens has just expired at her feet. The composition does not lack majesty, and the painting has been executed with quite a daring simplicity; Cleopatra's head is beautiful, and the negress's green and pink attire contrasts happily with the color of her skin. This huge picture has been successfully carried through with no regard for imitation, and it certainly contains something to please and attract the unattached *flâneur*.

Has it ever been your experience, as it has mine, that after spending long hours turning over a collection of bawdy prints, you fall into a great spell of melancholy? And have you ever asked yourself the reason for the charm sometimes to be found in rummaging among these annals of lubricity, which are buried in libraries or lost in dealers' portfolios—and sometimes also for the ill-humor which they cause you? It is a mixture of pleasure and pain, a vinegar for which the lips are always athirst! The pleasure lies in your seeing represented in all its forms that most important of natural feelings—and the anger in often finding it so badly copied or so stupidly slandered. Whether it has been by the fireside during the endless winter evenings, or in a corner of a dealer's shop, in the dog days when the hours hang heavy, the sight of such drawings has often put my mind into enormous drifts of reverie, in much the same way as an obscene book sweeps us toward the mystical oceans of the deep. Many times, when faced with these countless samples of the universal feeling, I have found myself wishing that the poet, the connoisseur, and the philosopher could grant themselves the enjoyment of a Museum of Love, where there would be a place for everything, from *St. Teresa*'s undirected affections down to the serious debaucheries of the ages of ennui. No doubt an immense distance separates *Le Départ pour l'île de Cythère*[1] from the miserable daubs which hang above a cracked pot and a

rickety side table in a harlot's room; but with a subject of such importance, nothing should be neglected. Besides, all things are sanctified by genius, and if these subjects were treated with the necessary care and reflection, they would in no wise be soiled by that revolting obscenity, which is bravado rather than truth.

Let not the moralist be too alarmed! I shall know how to keep the proper bounds, and besides, my dream is limited to a wish for this immense poem of love as sketched by only the purest hands—by Ingres, Watteau, Rubens, Delacroix! The playful and elegant princesses of Watteau beside the grave and composed Venuses of M. Ingres, the resplendent pearls of Rubens and Jordaens, and the sad beauties of Delacroix, just as one can imagine them—great, pale women, drowned in satin.[2]

And so, to give complete reassurance to the reader's startled modesty, let me say that I should class among erotic subjects not only all pictures which are especially concerned with love, but also any picture which suggests love, be it only a portrait.[3]

In this immense museum I envisage the beauty and the love of all climes, expressed by the leading artists—from the mad, scatterbrained *merveilleuses* which Watteau *fils*[4] has bequeathed us in his fashion engravings, down to Rembrandt's Venuses who are having their nails done and their hair combed with great boxwood combs, just like simple mortals.

Subjects of this nature are so important a thing that there is no artist, small or great, who has not devoted

himself to them, secretly or in public, from Giulio Romano to Devéria and Gavarni.

In general their great defect is a lack of sincerity and *naïveté*. I remember, however, a lithograph[5] which expresses one of the great truths of wanton love—though unhappily without too much refinement. A young man, disguised as a woman, and his mistress, dressed as a man, are seated side by side on a sofa—the sofa which you know so well, the sofa of the furnished lodgings and the private apartment. The young woman is trying to lift her lover's skirt.[6] In the ideal museum of which I was speaking, this lewd sheet would be counterbalanced by many others in which love would only appear in its most refined forms.

These reflections have occurred to me in connection with two pictures by M. Tassaert—*Erigone* and *Le Marchand d'esclaves*.

M. Tassaert, of whom I made the grave mistake of not saying enough last year, is a painter of the greatest merit, and one whose talent would be most happily applied to erotic subjects.

Erigone is half recumbent upon a mound overshadowed with vines—in a provocative pose, with one leg almost bent back, the other stretched out, and the body thrust forward; the drawing is fine, and the lines sinuous and expertly organized. Nevertheless I would criticize M. Tassaert, who is a colorist, for having painted this torso in too uniform a tone.

The other picture represents a market of women

awaiting buyers. These are true women, civilized women, whose feet have felt the rubbing of shoes; they are a little common, a little too pink perhaps, but a silly, sensual Turk is going to buy them as superfine beauties. The one who is seen from behind, and whose buttocks are enveloped in a transparent gauze, still wears upon her head a milliner's hat, a hat bought in the Rue Vivienne or at the Temple. The poor girl has doubtless been carried off by pirates!

The color of this picture is remarkable in the extreme for its delicacy and transparency of tone. One would imagine that M. Tassaert has been studying Delacroix's manner; nevertheless he has managed to retain a color of his own.

He is an outstanding artist, whom only the *flâneurs* appreciate and whom the public does not know well enough; his talent has never ceased growing, and when you think of whence he started, and where he has arrived, there is reason to look forward to ravishing things from him in the future.

There are two curiosities of a certain importance at the
Salon. These are the portraits of *Petit Loup* and of *Graisse
du dos de buffle* by M. Catlin, the impresario of the red-
skins.[1] When M. Catlin came to Paris, with his Museum
and his Ioways, the word went round that he was a good
fellow who could neither paint nor draw, and that if he
had produced some tolerable studies, it was thanks only
to his courage and his patience. Was this an innocent
trick of M. Catlin's, or a blunder on the part of the journal-
ists? For today it is established that M. Catlin can paint
and draw very well indeed. These two portraits would
be enough to prove it to me if I could not call to mind
many other specimens equally fine. I had been particu-
larly struck by the transparency and lightness of his skies.

M. Catlin has captured the proud, free character and
the noble expression of these splendid fellows in a mas-
terly way; the structure of their heads is wonderfully well
understood. With their fine attitudes and their ease of
movement, these savages make antique sculpture com-
prehensible. Turning to his color, I find in it an element
of mystery which delights me more than I can say. Red,
the color of blood, the color of life, flowed so abundantly
in his gloomy Museum that it was like an intoxication;
and the landscapes—wooded mountains, vast savan-
nahs, deserted rivers—were monotonously, eternally
green. Once again I find Red (so inscrutable and dense
a color, and harder to penetrate than a serpent's eye)—

and Green (the color of Nature, calm, gay, and smiling)—singing their melodious antiphon in the very faces of these two heroes. There is no doubt that all their tattooing and pigmentations had been done in accordance with the harmonious systems of nature.

I believe that what has led the public and the journalists into error with regard to M. Catlin is the fact that his painting has nothing to do with that *brash* style, to which all our young men have so accustomed us that it has become the *classic* style of our time.

Last year I already entered my protest against that unanimous *De profundis*—against that conspiracy of ingratitude—concerning the brothers Devéria. This year has proved me right. Many a precocious name which has been substituted for theirs is not yet worth as much. M. Achille Devéria has attracted special attention at this year's Salon by a picture, *Le Repos de la Sainte Famille*,[2] which not only retains all of that grace peculiar to these charming brother geniuses, but which also recalls the solid qualities of the older schools of painting—minor schools, perhaps, which do not precisely sweep the board either by their drawing or their color, but which, nevertheless, by their sense of order and of sound tradition are placed well above the extravagances proper to transitional ages. In the great battle of romanticism, the Devéria brothers were members of the sacred band of the colorists; and thus their place was marked out here. The composition of M. Achille Devéria's picture is excellent, and, over and above this, the eye is struck by its soft and harmonious appearance.

M. Boissard, whose beginnings were also brilliant and full of promise, is one of those excellent artists who have taken their nourishment from the old masters; his *Madeleine au désert* is good and sound in color—except for the flesh tones which are a trifle dingy. The pose is a happy one.

In this interminable Salon, where differences have been more than ever wiped out, and where everyone can draw and paint a little, but not enough to deserve even to be classed, it is a great joy to meet a frank and true painter like M. Debon. Perhaps his *Concert dans l'atelier*[3] is a little too *artistic* a picture—Valentin, Jordaens, and several others have their part in it; but at least it is fine, healthy painting, which marks its author as a man who is perfectly sure of himself.

M. Duveau has sent *Le Lendemain d'une tempête*. I do not know if he has it in him to become a frank colorist, but some parts of his picture give hopes of it. At first sight you search your memory for some historical scene which it can represent; for in fact the English are almost alone in daring to paint genre pictures of such vast proportions. Nevertheless it is well organized and in general seems well designed. The tonality, which is a little too uniform and offends the eye at first, is doubtless based on an effect of nature, all of whose features appear singularly crude in color after being washed by the rains.

M. Laemlein's *Charité*[4] is a charming woman with a whole bunch of little brats of all countries—white, yellow, black, and so on—held by the hand or carried at the breast. Certainly M. Laemlein has a feeling for good

color. If his picture contains one great fault, it is that the little Chinaman is so pretty, and his garment so delightful to the eye, that he practically monopolizes the spectator's attention. This little mandarin never stops trotting through the memory, and he will cause many people to forget all the rest.

M. Decamps is one of those who, for many years now, have tyrannically possessed the public's interest; and nothing could be more legitimate.

This artist, who is gifted with a marvelous capacity for analysis, used often to achieve powerfully effective results by means of a happy conflict of little tricks. If he shirked linear detail too much, often contenting himself with movement and general contour, and if his drawing used occasionally to verge upon the *chic*, nevertheless his meticulous taste for Nature, studied above all in her effects of light, always kept him safe and sustained him on a superior plane.

If M. Decamps was not precisely a draftsman in the generally accepted sense of the word, nevertheless, in his own way and in a particular fashion, he was one. No one has seen large figures from his pencil; but certainly the drawing—that is to say, the *build*—of his little manikins was brought out and realized with remarkable boldness and felicity. Their bodily nature and habits were always clearly revealed; for M. Decamps can make a figure intelligible in a few lines. His sketches were diverting and profoundly comical. It was the draftsmanship of a wit, almost of a caricaturist; for he possessed an extraordinary

geniality, or mocking fancy, which was a perfect match for the ironies of nature; and so his figures were always posed, draped, or dressed in accordance with the truth and with the eternal proprieties and habits of their persons. If there was a certain immobility in his drawing, this was by no means unpleasing, and actually put the seal upon his orientalism. Normally he took his models in repose; and when they were shown running, they often reminded you of frozen shadows or of silhouettes suddenly halted in their course; they ran as though they were part of a bas-relief. But it was color that was his strong suit, his great and unique affair. Now M. Delacroix is without doubt a great colorist; but he is not a fanatical one. He has many other concerns, and the scale of his canvases demands it. But for M. Decamps color was the great thing; it was, so to speak, his favorite mode of thought. His splendid and radiant color had, what is more, a style very much of its own. It was, to use words borrowed from the moral order, both sanguinary and mordant. The most appetizing dishes, the most thoughtfully prepared kickshaws, the most piquantly seasoned products of the kitchen, had less relish and tang, and exhaled less fierce ecstasy upon the nose and the palate of the epicure than M. Decamps's pictures possessed for the lover of painting. Their strangeness of aspect halted you, held you captive, and inspired you with an irresistible curiosity. Perhaps this had something to do with the unusual and meticulous methods which the artist often employs—for he *lucubrates* his painting, they say, with the tireless will

of an alchemist. So sudden and so novel was the impression that it produced upon the mind of the spectator at that time, that it was difficult to conceive its ancestry, or to decide who had fathered this singular artist, and from what studio this solitary and original talent had emerged. Certainly a hundred years from now historians will have trouble in identifying M. Decamps's master. Sometimes he seemed to stem from the boldest colorists of the old Flemish school, but he had more style than they, and he grouped his figures more harmoniously; sometimes the splendor and the triviality of Rembrandt were his keen preoccupation; at other times his skies would suggest a loving memory of the skies of Claude. For M. Decamps was a landscape painter too, and, what is more, a landscape painter of the greatest merit. But his landscapes and his figures formed a single whole and helped one another mutually; one had no more importance than the other, for with him nothing was an accessory—so curiously wrought was every part of his canvas, and to such an extent was each detail planned to contribute to the total effect! Nothing was unnecessary—not even the rat swimming across a tank in one or other of his Turkish pictures—a picture all lethargy and fatalism; nor even the birds of prey which hover in the background of that masterpiece entitled *Le Supplice des Crochets*.

At that time the sun and light played a great part in M. Decamps's painting. No one studied atmospheric effects with so much care. The weirdest and most improbable tricks of shadow and light pleased him more than

anything. In a picture by M. Decamps the sun seemed really to scorch the white walls and the chalky sands; every colored object had keen and lively transparency. The waters were of untold depth; the great shadows which used to cut across the flanks of his houses or to sleep stretched out upon the ground or the water had the languor and sweet drowsiness of shadows beyond description. And in the midst of his fascinating decor, you would find little figures bestirring themselves or dreaming—a complete little world in all its native and comic truth.

Yes, M. Decamps's pictures were full of poetry, and often of reverie; but what others, like Delacroix, would achieve by great draftsmanship, by an original choice of model or by broad and flowing color, M. Decamps achieved by intimacy of detail. The only criticism, in fact, which you could make, was that he was too concerned with the material execution of objects; his houses were made of true plaster and true wood, his walls were made of true lime-mortar; and in front of these masterpieces, the heart was often saddened by a painful idea of the time and the trouble which had been devoted to their making. How much finer they would have been if executed less artfully!

Last year, when M. Decamps took up a pencil and thought fit to challenge Raphael and Poussin, the enthusiastic *flâneurs* of both parties—men whose hearts embrace the whole world, but who are quite content with things as the Almighty has designed them, and who, all of them, adored M. Decamps as one of the rarest products

of creation—these men said among themselves: "If Raphael prevents Decamps from sleeping, then it's no more Decampses for us! Who will do them now—? Alas! It will be MM. Guignet and Chacaton."

All the same, M. Decamps has reappeared this year with some Turkish things, some landscapes, some genre pictures, and an *Effet de Pluie*.[5] But you have to look for them; they no longer strike the eye at once.

M. Decamps, who is so good at giving us the sun, has failed, however, with the rain; besides, he has given his ducks a slab of stone to swim on, etc. His *Ecole turqe*, nevertheless, is more like his best pictures; there they all are, those lovely children whom we know so well, and that luminous, dust-charged atmosphere of a room which the sun is trying to enter bodily.

It seems to me so easy to console ourselves with the magnificent Decampses which already adorn our galleries, that I do not want to analyze the faults of these ones. It would be a senseless task, and besides everyone will do it very well for himself without any help from me.

Among the paintings by M. Penguilly-l'Haridon,[6] which are all good pieces of workmanship—little pictures, broadly, yet finely painted—there is one that especially stands out and attracts the eye: *Pierrot présente à l'assemblée ses compagnons Arlequin et Polichinelle*.[7]

Pierrot, with one eye open and the other closed, and that crafty air which is traditional, is presenting Harlequin to the public; Harlequin advances with sweeping and obsequious gestures, and with one leg gallantly

pointed in front of him. Punchinello follows him, with swimming head, fatuous glance, and his poor little legs in great big sabots. A ridiculous face, with a huge nose, huge spectacles, and a huge curled moustache, appears between two curtains. The color of the whole thing is pleasing—both simple and fine—and the three characters stand out perfectly against a gray background. But the thrilling effect of this picture is less the result of its general appearance than of its composition, which is excessively simple. The figure of Punchinello, which is essentially comic, reminds us of the English Punch, who is usually shown touching the end of his nose with his index finger, to express his pride in it, or his vexation. I would, however, criticize M. Penguilly for not having taken his type from Deburau,[8] who is the true Pierrot of today—the Pierrot of modern history—and should therefore have his place in any painted harlequinade.

Now here is another fantasy, which is very much less adroit and less learned, and whose beauty is all the greater in that it is perhaps involuntary; I refer to M. Manzoni's *La Rixe des mendiants*. I have never seen anything so poetically brutal, even in the most Flemish of orgies. Here, under six heads, are the different reactions of the visitor who passes in front of his picture: 1. Lively curiosity, 2. "How shocking!" 3. "It's badly painted, but the composition is unusual and does not lack charm," 4. "It's not so badly painted as we thought at first," 5. "Let's have another look at this picture," and 6. A lasting memory.

It has a ferocity and a brutality of manner which suit the subject rather well and put us in mind of Goya's violent sketches. These, in fact, are the most ruffianly countenances that you could wish to see: it is a weird conglomeration of battered hats, wooden legs, broken glasses, befuddled topers; lust, ferocity, and drunkenness are shaking their rags.

The ruddy beauty who is kindling the desires of these gentlemen is a fine stroke of the brush, and well formed to please the connoisseurs. I have rarely seen anything so comic as that poor wretch up against a wall, whom his neighbor has victoriously nailed with a pitchfork.

The second picture, *L'Assassinat nocturne*, has a less strange look. Its color is dim and commonplace, and the fantastic ingredient is confined to the manner in which the scene is represented. A beggar is brandishing a knife in the face of a miserable fellow whose pockets are being ransacked and who is half dead from fear. Those white dominoes, in the form of gigantic noses, are very droll and give the most singular stamp to this scene of terror.

M. Villa-Amil has painted the throne room in Madrid. At first sight, you might say that it was very simply executed; but if you look at it with more care, you will recognize a lot of cleverness in the organization and in the general coloring of this decorative picture. It is less fine in tone, perhaps, but it is firmer in color than the pictures of the same type for which M. Roberts[9] has a liking. If it has a fault, it is that the ceiling looks less like a ceiling than a real sky.

MM. Wattier and Pérèse generally treat almost similar subjects—fair ladies wearing old-fashioned costumes, in parks, beneath ancient shades. What distinguishes M. Pérèse is that he paints with much more simplicity, and his name does not compel him to ape Watteau. But in spite of the studied delicacy of M. Wattier's figures, M. Pérèse is his superior in invention. You might say that there is the same difference between their works as between the mincing gallantry of the age of Louis xv and the honest gallantry of the age of Louis xiii.

The school of Couture—since we must call it by its name—has given us much too much this year.

M. Diaz de la Peña,[10] who is, in little, the extreme representative of this *little* school, sets out from the principle that a palette is a picture. As for overall harmony, M. Diaz thinks that you will invariably find it. Of draftsmanship—the draftsmanship of movement, the draftsmanship of the colorists—there is no question; the limbs of all the little figures behave for all the world like bundles of rags, or like arms and legs scattered in a railway accident. I would far rather have a kaleidoscope; at least it does not presume to give us *Les Délaissées* or *Le Jardin des amours*—it provides designs for shawls and carpets, and its role is a modest one. It is true that M. Diaz is a colorist; but enlarge his frame by a foot, and his strength will fail him, because he does not recognize the necessity for *general* color. That is why his pictures leave no memory behind them.

But each man has his allotted part, you say. Great

painting is not made for everyone, by any means. A fine dinner contains both hors d'oeuvres and main courses. Would you dare to sneer at the Arles sausages, the pimentoes, the anchovies, the aioli, and the rest?—Appetizing hors d'oeuvres? I reply. Not a bit of it. These things are bonbons and nauseating sweetmeats. Who would want to feed on dessert? You hardly do more than just touch it when you are pleased with your dinner.

M. Célestin Nanteuil knows how to place a brushstroke, but he does not know how to fix the proportions and the harmony of a picture.

M. Verdier paints well enough, but fundamentally I believe him to be an enemy of thought.

M. Muller, the man of the *Sylphes*, the great connoisseur of poetic subjects—of subjects streaming with poetry—has painted a picture which he calls *Primavera*. People who do not know Italian will think that this word means *Decameron*.

M. Faustin Besson's color loses much by being no longer dappled and befogged by the windows of Deforge's shop.[11]

M. Fontaine is obviously a serious-minded man; he has given us M. de Béranger surrounded by youngsters of both sexes, whom he is initiating into the mysteries of Couture's manner.

And what great mysteries they are! A pink or peach-colored light, and a green shadow—that's all there is to it! The terrible thing about this painting is that it forces itself upon the eye; you notice it from a great distance.

Without a doubt the most unfortunate of all these gentlemen is M. Couture himself, who throughout plays the interesting role of victim. An imitator is a babbler who gives away secrets.

In the various specialties of Bas-Breton, Catalan, Swiss, Norman subjects and the rest, MM. Armand and Adolphe Leleux are outstripped by M. Guillemin, who is inferior to M. Hédouin, who himself yields the palm to M. Haffner.

Several times I have heard this peculiar criticism directed at the MM. Leleux—that whether they were supposed to be Swiss, Spanish, or Breton, all their characters seemed to come from Brittany.

M. Hédouin is certainly a commendable painter, who possesses a firm touch and understands color; no doubt he will succeed in establishing his own particular originality.

As for M. Haffner, I owe him a grudge for once having painted a portrait in a superbly romantic style, and for having painted no more like it.[12] I believed that he was a great artist, rich in poetry and, above all, in invention, a portraitist of the front rank, who came out with an occasional daub in his spare time; but it seems that he is no more than just a painter.

Since color is the most natural and the most *visible* thing, the party of the colorists is the most numerous and the most important. But analysis, which facilitates the artist's means of execution, has divided nature into color and line; and before I proceed to an examination of the men who form the second party, I think that it would be well if I explained some of the principles by which they are guided—sometimes even without their knowing it.

The title of this chapter is a contradiction, or rather an agreement of contraries; for the drawing of a great draftsman ought to epitomize both things—the ideal and the model.

Color is composed of colored masses which are made up of an infinite number of tones, which, through harmony, become a unity; in the same way, Line, which also has its masses and its generalizations, can be subdivided into a profusion of particular lines, of which each one is a feature of the model.

The circumference of a circle—the ideal of the curved line—may be compared with an analogous figure, composed of an infinite number of straight lines which have to fuse with it, the inside angles becoming more and more obtuse.

But since there is no such thing as a perfect circumference, the absolute ideal is a piece of nonsense. By his exclusive taste for simplicity, the idiotic artist is led to a perpetual imitation of the same type. But poets, artists,

and the whole human race would be miserable indeed if the ideal—that absurdity, that impossibility—were ever discovered. If that happened, what would everyone do with his poor *ego*—with his crooked line?

I have already observed that memory is the great criterion of art; art is a kind of mnemotechny of the beautiful. Now exact imitation spoils a memory. There are some wretched painters for whom the least wart is a stroke of luck; not only is there no fear of their forgetting it, but they find it necessary to paint it four times as large as life. And thus they are the despair of lovers— and when a people commissions a portrait of its king, it is nothing less than a lover.

A memory is equally thwarted by too much particularization as by too much generalization. I prefer the *Antinous* to the *Apollo Belvedere* or to the *Gladiator*, because the *Antinous* is the ideal of the charming Antinous himself.

Although the universal principle is one, Nature presents us with nothing absolute, nothing even complete;[1] I see only individuals. Every animal of a similar species differs in some respect from its neighbor, and among the thousands of fruits that the same tree can produce, it is impossible to find two that are identical, for if so, they would be one and the same; and duality, which is the contradiction of unity, is also its consequence.[2] But it is in the human race above all that we see the most appalling capacity for variety. Without counting the major types which nature has distributed over the globe,

every day I see passing beneath my window a certain number of Kalmouks, Osages, Indians, Chinamen, and ancient Greeks, all more or less Parisianized. Each individual is a unique harmony; for you must often have had the surprising experience of turning back at the sound of a known voice and finding yourself face to face with a complete stranger—the living reminder of someone else endowed with a similar voice and similar gestures. This is so true that Lavater has established a nomenclature of noses and mouths which agree together, and he has pointed out several errors of this kind in the old masters, who have been known to clothe religious or historical characters in forms which are contrary to their proper natures. It is possible that Lavater was mistaken in detail; but he had the basic idea. Such and such a hand demands such and such a foot; each epidermis produces its own hair. Thus each individual has his ideal.

I am not claiming that there are as many fundamental ideals as there are individuals, for the mold gives several impressions; but in the painter's soul there are just as many ideals as individuals, because a portrait is a *model complicated by an artist*.

Thus that ideal is not that vague thing—that boring and impalpable dream—which we see floating on the ceilings of academies; an ideal is an individual put right by an individual, reconstructed and restored by brush or chisel to the dazzling truth of its native harmony.

The first quality of a draftsman is therefore a slow and sincere study of his model. Not only must the artist

have a profound intuition of the character of his model; but further, he must generalize a little, he must deliberately exaggerate some of the details, in order to intensify a physiognomy and make its expression more clear.

It is curious to note that, when guided by this principle—namely, that the sublime ought to avoid details—art finds the way of self-perfection leading back toward its childhood. For the first artists also used not to express details. The great difference, however, is that, in doing the arms and the legs of their figures like drainpipes, it was not *they* who were avoiding the details, but the details which were avoiding *them*; for in order to choose, you have first to possess.

Drawing is a struggle between nature and the artist, in which the artist will triumph the more easily as he has a better understanding of the intentions of nature. For him it is not a matter of copying, but of interpreting in a simpler and more luminous language.

The introduction of the portrait—that is to say, of the idealized model—into historical, religious, or imaginative subjects necessitates at the outset an exquisite choice of model, and is certainly capable of rejuvenating and revitalizing modern painting, which, like all our arts, is too inclined to be satisfied with the imitation of the old masters.

Everything else that I might say on the subject of ideals seems to me to be contained in a chapter of Stendhal, whose title is as clear as it is insolent:

How are we to go one better than Raphael?

In the affecting scenes brought about by the passions, the great painter of modern times—if ever he appears—will give to each one of his characters *an ideal beauty, derived from a temperament* which is constituted to feel the effect of that passion with the utmost vividness.

Werther will not be indifferently sanguine or melancholic, nor Lovelace phlegmatic or bilious. Neither good Doctor Primrose nor gentle Cassio will have a bilious temperament; this is reserved for Shylock the Jew, for dark Iago, for Lady Macbeth, for Richard III. The pure and lovely Imogen will be a trifle phlegmatic.

The artist's first observations led him to fashion the *Apollo Belvedere*. But will he restrict himself to coldly producing copies of the Apollo every time that he wishes to represent a young and handsome god? No, he will set a link between the action and the type of beauty. Apollo delivering the Earth from the serpent Python will be more robust; Apollo paying court to Daphne will be more delicate of feature.[3]

VIII. SOME DRAFTSMEN

In the preceding chapter I said nothing at all about imaginative or creative draftsmanship, because in general this is the prerogative of the colorists. Michelangelo, who, from a certain point of view, is the inventor of the ideal among the moderns, is the only man to have possessed the "graphic" imagination in its supreme degree without being a colorist. Pure draftsmen are naturalists endowed with excellent perception; but they draw by the light of reason, whereas colorists—that is, *great* colorists—draw by the light of temperament, almost without knowing it. Their method is analogous to nature; they draw because they color, whereas pure draftsmen, if they wanted to be logical and true to their profession of faith, would content themselves with a black pencil. Nevertheless they devote themselves to color with an unimaginable enthusiasm, taking no notice at all of the contradictions involved. They start by delimiting their forms in a cruel and absolute manner, and they proceed to fill up the spaces. This double method ceaselessly thwarts their efforts, and gives to all their productions a strange element of bitterness, toil, and contention. Their works are an eternal piece of litigation, an exhausting dualism. A draftsman is a would-be colorist.

This is so true that M. Ingres, the most illustrious representative of the naturalistic school of draftsmanship, is forever in pursuit of color. What admirable and unfortunate obstinacy! It is the eternal story of people

wanting to trade a reputation which they have earned for one which cannot win. M. Ingres adores color, like a fashionable milliner. It is at once a pain and a pleasure to observe the efforts which he makes in choosing and coupling his tones. The result—which is not always discordant, but is nevertheless bitter and violent—is often pleasing to corrupt poets; but even so, when they have allowed their tired minds a long spell of amusement in the midst of these dangerous struggles, they feel an absolute need to come to rest upon a Velázquez or a Lawrence.

If M. Ingres occupies the most important place after Eugène Delacroix, it is because of that entirely personal draftsmanship whose mysteries I was analyzing a moment ago, and with which he has achieved the best epitome to date of the ideal and the model. M. Ingres draws admirably well, and he draws rapidly. In his sketches he attains the ideal quite naturally. His drawing is often only lightly charged and does not contain many strokes; but each one realizes an important contour. But now take a look at the drawings of all those *artisans* of painting—many of them his pupils; they start by rendering the minute details, and it is for this reason that they enchant the vulgar, which will only open its eye for what is *little*, in whatever genre.

In a certain sense M. Ingres draws better than Raphael, the popular king of draftsmen. Raphael decorated immense walls: but he would not have done the portrait of your mother, your friend, or your mistress so well as

Ingres. The daring of this man is all his own, and it is combined with cunning in such a way that he shirks no sort of ugliness or oddity. Did he stop at M. Molé's frock-coat[1] or Cherubini's *carrick*? And did he not put a blind man, a one-eyed and a one-armed man, and a hunchback into the *Plafond d'Homère*[2]—a work which, more than any other, aspires toward the ideal? Nature repays him handsomely for the pagan adoration. He could make a sublime thing even of Mayeux.[3]

The beautiful *Muse de Cherubini*[4] is still a portrait. If M. Ingres, who lacks the "graphic" imagination, does not know how to make pictures—at least, on a large scale—it is nevertheless just to say that his portraits are *almost* pictures—that is, intimate poems.

His is a grudging, cruel, refractory, and suffering talent—a singular mixture of contrary qualities, all placed to the credit of Nature, and one whose strangeness is not among its least charms. He is Flemish in his execution, an individualist and a naturalist in his drawing, antique by his sympathies and an idealist by reason.

To reconcile so many contraries is no meager task; and so it is not without reason that, in order to display the sacred mysteries of his draftsmanship, he has adopted an artificial system of lighting which serves to render his thought more clear—something similar to the sort of twilight in which a still-sleepy Nature has a wan and raw appearance and in which the countryside reveals itself in a fantastic and striking guise.

A rather distinctive fact about M. Ingres's talent, and one which I believe has been overlooked, is that he is happier in dealing with female subjects. He depicts them as he sees them, for it would appear that he loves them too much to wish to change them; he fastens upon their slightest beauties with the keenness of a surgeon, he follows the gentlest sinuosities of their line with the humble devotion of a lover. His *Angelique*,[5] his two *Odalisques*, and his portrait of Mme d'Haussonville[6] are works of a deeply sensuous rapture. But we are never allowed to see any of these things except in a light which is almost frightening—it is neither the golden atmosphere in which the fields of the ideal lie bathed, nor yet the tranquil and measured light of the sublunar regions.

The works of M. Ingres are the result of an excessive attentiveness, and they demand an equal attentiveness in order to be understood. Born of suffering, they beget suffering. As I explained above, this is due to the fact that his method is not one and simple, but rather consists in the use of a succession of methods.

Around M. Ingres, whose teaching has a strange austerity which inspires fanaticism, there is a small group of artists, of whom the best-known are MM. Flandrin, Lehmann, and Amaury-Duval.

But what an immense distance separates the master from his pupils! M. Ingres remains alone in his school. His method is the result of his nature and however weird and uncompromising it may be, it is frank and, so to speak, involuntary. Passionately in love with the antique

and with his model, and a respectful servant of nature, he paints portraits which can rival the best sculptures of the Romans. These gentlemen, however, have coldly, deliberately, and pedantically chosen the unpleasant and unpopular part of his genius to translate into a system; it is their pedantry that preeminently distinguishes them, Curiosity and erudition are what they have seen and studied in their master. Hence their pursuit of leanness and pallor, and all the rest of those ridiculous conventions which they have adopted without examination or good faith. They have plunged deep, very deep, into the past, just in order to copy its deplorable mistakes with a puerile servility; they have deliberately discarded all the means of successful execution which the experience of the ages had made available to them. People still remember *La Fille de Jephté pleurant sa virginité*;[7] but those excessive elongations of hands and feet, those exaggerated ovals of heads, all those ridiculous affectations—conventions and habits of the brush which have a tolerable resemblance to the *chic*—are singular faults in an ardent worshipper of form. Since his portrait of the Princess Belgiojoso, M. Lehmann has never ceased painting abnormally big eyes, in which the pupil swims like an oyster in a soup tureen. This year he has sent some portraits and some other pictures. The pictures are *Les Océanides*, *Hamlet*, and *Ophelia*. *Les Océanides* is a sort of Flaxman, and its general aspect is so ugly that it kills any desire to examine the design. In the portraits of Hamlet and Ophelia[8] there are visible pretensions to *color*—

the great hobby-horse of this school! But this unfortu-
nate imitation of color is as saddening and distressing
to me as a copy of a Veronese or a Rubens made by an
inhabitant of the moon. As for their physical and spiri-
tual deportment, these two figures reminded me of the
bombast of the actors at the old Bobino, when they used
to play melodramas there. Without a doubt Hamlet's
hand is fine; but a well-executed hand does not make a
draftsman—that would really be asking too much of *de-
tail*, even for an Ingrist!

I think that Mme Calamatta also belongs to the party
of the enemies of the sun; but sometimes her pictures
are quite happily composed and they have a little of that
air of authority which women—even the most literary
of them, and the real *artists*—find it less easy to borrow
from men than their absurdities.

M. Janmot has done a *Station—Le Christ portant sa
Croix*—whose composition has some character and
gravity, but whose color, being no longer mysterious, or
rather *mystical*, as in his last works, is unhappily remi-
niscent of the color of all possible *Stations*. As you look at
this crude and glossy picture, it is only too easy to guess
that M. Janmot comes from Lyons. In fact this is just the
kind of painting which suits that city of cash-tills—that
city of bigotry and punctilio, where everything, down
to religion, has to have the calligraphic neatness of an
account book.[9]

The names of M. Curzon and M. Brillouin have al-
ready often been linked in the public mind, although

at the start they gave promise of more originality. This year M. Brillouin—*A quoi rêvent les jeunes filles*[10]—has stepped out of himself, and M. Curzon has been content to do Brillouins. Their tendency reminds one of the school of Metz—a literary, mystical, and *Germanic* school. M. Curzon, who often paints fine, generously colored landscapes, could interpret Hoffmann in a less erudite, a less conventional way. But although he is obviously a man of wit—his choice of subjects is enough to prove it—you feel that the Hoffmannesque afflatus has passed nowhere near him.[11] The old-fashioned style of the German artists bears no resemblance to the style of this great poet, whose compositions have a very much more modern and more romantic character. The artist has vainly tried to obviate this capital defect by choosing the least fantastic of all the stories, *Master Martin and his Apprentices*, of which Hoffmann himself said: "It is the most mediocre of my works; there is not a shred of the terrible or the grotesque in it, and these are the two most important arrows in my quiver!" But in spite of that, even in *Master Martin* Hoffmann's lines are more floating and his atmosphere more supernatural than M. Curzon has made them.

Properly speaking M. Vidal's place is not here at all, for he is not a true draftsman. Nevertheless the moment is not too badly chosen, for he has several of the ridiculous fads of the Ingrists—that is to say, a fanatical regard for the *little* and the *pretty*, and an enthusiasm for beautiful paper and fine canvases. All this has nothing to do

with the sense of order with which a strong and vigorous mind is ruled and girt, nor yet with the adequate neatness of a man of good sense; it is a neatness run mad.

The preconception about Vidal began, I think, three or four years ago. Even so, at that time his drawings were less pedantic and less mannered than they are today.

This morning I was reading an article by M. Théophile Gautier,[12] in which he sang the praises of M. Vidal for being able to interpret modern beauty. I do not know why M. Gautier has donned the uniform of the "good-natured man" this year; for he has praised everyone, and there is no wretched dauber whose pictures he has not catalogued. Can it be perchance that the hour of the Academy—that solemn and soporific hour—has struck for him, if he is already so well-mannered? And has literary prosperity such disastrous results that the public is forced to call us to order by rubbing our noses in our original certificates of romanticism? Nature has endowed M. Gautier with an excellent, broad, and poetic mind. Everyone knows what fierce admiration he has always evinced for sincere and generous works. What potion can the painters have poured into his wine this year? Or what rose-tinted spectacles has he selected with which to go to work?

So M. Vidal understands modern beauty, does he? Come now! Thanks to nature, our women have not so much wit or sophistication; but they are infinitely more romantic. Look at nature, sir. A man does not arm himself with wit and with meticulously sharpened pencils

in order to *paint*! For some critics rank you—I really do not know why—among the noble family of painters. It is no use you calling your women *Fatinitza*,[13] *Stella*, *Vanessa*, *Saison des Roses*[14]—a bunch of names for cosmetics; you will not produce poetic women that way. You once set yourself the task of expressing the idea of *Self-love*[15]—a great and fine idea, a supremely feminine idea—but you quite failed to interpret the sharp element of greed and the magnificent egoism of the subject. You never rose above puerile obscurity.

Nevertheless all these affectations will pass away like rancid unguents. A ray of sunshine is enough to bring out all their stench. I would rather leave Time to do its work than waste my own in expounding all the poverties of this sorry genre.

There are two ways of understanding portraiture—either as history or as fiction.

The first is to set forth the contours and the modeling of the subject faithfully, severely, and minutely; this does not however exclude idealization, which, for enlightened naturalists, will consist in choosing the sitter's most characteristic attitude—the attitude which best expresses his habits of mind. Further, one must know how to give a reasonable exaggeration to each important detail—to lay stress on everything which is naturally salient, marked, and essential, and to disregard (or to fuse with the whole) everything which is insignificant or which is the effect of some accidental blemish.

The masters of the "historical" school are David and Ingres, and its best manifestations are the portraits by David which were to be seen at the Bonne Nouvelle exhibition,[1] and those of M. Ingres, such as M. Bertin and Cherubini.[2]

The second method, which is the special province of the colorists, is to transform the portrait into a picture—a poem with all its accessories, a poem full of space and reverie. This is a more difficult art, because it is a more ambitious one. The artist has to be able to immerse a head in the soft haze of a warm atmosphere, or to make it emerge from depths of gloom. Here the imagination has a greater part to play, and yet, just as it often happens that fiction is truer than history, so it can happen that a

model is more clearly realized by the abundant and flowing brush of a colorist than by the draftsman's pencil.

The masters of the "fictional," or "romantic," school are Rembrandt, Reynolds, and Lawrence. Well-known examples are *La Dame au chapeau de paille*[3] and *Master Lampton*.[4]

A characteristic excellence of MM. Flandrin, Amaury-Duval, and Lehmann is the truth and subtlety of their modeling. The detail is well grasped and executed easily and all in one breath, so to speak; nevertheless their portraits are often vitiated by a pretentious and clumsy affectation. Their immoderate taste for *distinction* never ceases to trip them up. We know with what an admirable simplicity of mind they seek after *distinguished* tones—that is to say, tones which, if intensified, would scream at one another like the devil and holy water, or like marble and vinegar; but since these are excessively etiolated and given in homeopathic doses, their effect is one of surprise rather than of pain; and that is their great triumph!

The *distinction* in their draftsmanship consists in their sharing the prejudices of certain modish ladies, who have a smattering of debased literature and a horror of little eyes, large feet, large hands, little brows, and cheeks glowing with joy and health—all of which can be extremely beautiful.

This pedantry in color and draftsmanship does constant injury to the works of these gentlemen, however estimable they may be in other respects. Thus, while I was contemplating M. Amaury-Duval's *blue* portrait (and

the same applies to many other portraits of Ingresque, or *Ingrized*, women), some strange association of ideas brought to mind the following wise words of the dog Berganza,[5] who used to run away from *bluestockings* as ardently as these gentlemen seek them out:

"Have you never found Corinne[6] quite impossible? ... At the idea of seeing her come near me, in flesh and blood, I used to feel an almost physical oppression, and found myself quite incapable of preserving my serenity and freedom of mind in her presence.... Whatever the beauty of her arms or her hand, I could never have endured her caresses without feeling slightly sick—without a kind of internal shudder which tends to take away my appetite.... Of course I am only speaking here in my canine capacity!"

I have had the same sensation as the witty Berganza in front of nearly all the portraits of women—whether old or new ones—by MM. Flandrin, Lehmann, and Amaury-Duval; and this in spite of the beautiful hands (really well-painted, too) which they know how to give them, and in spite of the flattering elegance of certain details. If Dulcinea del Toboso herself were to pass through the studio of these gentlemen, she would emerge as pellucid and prim as an elegy, after a slimming diet of aesthetic tea and aesthetic butter.

M. Ingres, however—and this must be repeated over and over again—M. Ingres, the great master, understands things in quite another way.

In the sphere of portraiture understood according to the second method, MM. Dubufe the elder, Winter-

chic"—a dreadful word of modern inven-
I do not even know how to spell correctly,[1]
I am obliged to use, because it has been
by artists in order to describe a modern
y—the word "chic" means a total neglect of
nd of nature. The "chic" is an abuse of the
oreover it is a manual, rather than an intel-
nory that it abuses—for there are artists who
ith a profound memory for characters and
acroix or Daumier, for example—and who
g to do with it.

c" may be compared with the work of those
sters who, with an elegant hand and a pen
talic or running script, can shut their eyes
race a head of Christ or Napoleon's hat, in
a flourish.

ning of the word "poncif"[2] has much in com-
at of the word "chic." Nevertheless it applies
ularly to attitudes and to the expressions of

be "poncif," and so can astonishment—for
e kind of astonishment expressed by a hori-
vith the thumb splayed out.
certain beings and things, in life and nature,
oncif"—that is to say, which are an epitome
and banal ideas which are commonly held
beings and those things; great artists, there-
norror of them.

halter, Lépaulle, and Mme Frédérique O'Connell, given
a sincerer taste for nature and a solider color, might have
won a justifiable reputation.

M. Dubufe is destined to retain the privilege of ele-
gance in portraiture for a long time yet; his natural and
almost poetic taste successfully conceals his innumer-
able faults.

It is worth observing that the people who hurl the
word "bourgeois" so frequently at M. Dubufe are the very
ones who have allowed themselves to be enchanted by
M. Pérignon's wooden heads. How much one would have
forgiven M. Delaroche if it had been possible to foresee
the Pérignon factory!

M. Winterhalter is really on the decline. M. Lépaulle
is still the same, now and again an excellent painter, but
always devoid of taste and good sense. Charming eyes
and mouths, well-executed arms—and *toilettes* calcu-
lated to send decent people running!

Mme O'Connell knows how to paint with freedom
and rapidity; but her color lacks firmness. That is the un-
happy fault of English painting, which is transparent to
excess and is always characterized by too great a fluidity.[7]

An excellent example of the kind of portrait whose
essence I was attempting to define a moment ago is that
portrait of a woman by M. Haffner—drenched in gray and
radiating mystery—which led the connoisseurs at the
last Salon to entertain such high hopes; but M. Haffner
had not yet become a genre painter, seeking to fuse and
to reconcile Diaz, Decamps, and Troyon.

97

You would suppose that Mlle E. Gautier was seeking to modify her manner a little. She is wrong to do so.

MM. Tissier and J. Guignet have preserved their touch and their color, which are both firm and solid. Generally speaking there is this excellent quality about their portraits, that they are above all pleasant to look at—that is the first impression, and the most important.

M. Victor Robert, the creator of a vast allegory of Europe,[8] is certainly a good painter, gifted with a firm hand. But an artist who undertakes the portrait of a famous man ought not to be content to achieve a merely felicitous paint-surface; for he is also painting the portrait of a mind. M. Granier de Cassagnac[9] is much uglier, or, if you prefer it, much more handsome. To start with he has a broader nose, and his mouth, which is mobile and sensitive, has a slyness and a delicacy which the painter has missed. M. Granier de Cassagnac seems somehow smaller and more athletic—down to his very brow. The present pose is theatrical rather than expressive of the genuine force which characterizes the man. It gives no hint of that challenging and martial bearing with which he attacks life and all its problems. It is enough to have seen him suddenly thunder forth his passions, with leaps and starts of pen and chair—it is enough simply to have read them in the paper—to realize that the whole man is not here. The copy of *Le Globe*, which recedes into the shadow, is a complete absurdity—surely it ought to have been in full view, if it had to be there at all!

I have always had the n
have made an excellent
man, quite devoid of in
working on someone els
tures are bad, but his po
easily and simply painted
they often have the look o
ter the portraits of Van Dy
ows and the bright highlig
time that M. Boulanger h
fallen into bathos. I belie
calm, and sound intellig
ated praises of the poets c

What am I to say of M.
tic, that painter of such s
intelligence that, in order
properly, he has had the i
to M. Granet's own pictur
as we have all known for a

Mme de Mirbel is the c
thread her way through tl
and truth. It is because of t
because of their enchantin
tures have all the importa

The wor
tion, whi
but whic
sanction
monstro
the mod
memory
lectual, r
are gifte
forms—
have not

The "
writing-
shaped
and bol
the form

The
mon wit
more pa
the hea

Rag
exampl
zontal a

The
which a
of the v
about t
fore, h

Everything is conventional and traditional owes something to the "chic" and the "poncif."

When a singer places his hand upon his heart, this commonly means "I shall love her always!" If he clenches his fists and scowls at the boards or at the prompter, it means "Death to him, the traitor!" That is the "poncif" for you.

Such are the stern principles which guide this eminently *national* artist in his quest for beauty—this artist whose compositions decorate the poor peasant's cottage no less than the carefree student's garret, the salon of the meanest bordello as often as the palaces of our kings. I am quite aware that this man is a Frenchman, and that a Frenchman in France is a holy and sacred thing—even abroad I am told that this is so; but it is for that very reason that I hate him.

In its most widely accepted sense, the word "Frenchman" means *vaudevilliste*,[1] and the word "vaudevilliste" means a man whose head swims at the thought of Michelangelo, and whom Delacroix strikes into a brutish stupor, just as certain animals are struck by thunder. Everything that towers or plunges, above or below him, causes him prudently to take to his heels. The sublime always affects him like a riot, and he only opens his Moliere in fear and trembling—because someone has persuaded him that Moliere is an amusing author.

Therefore all respectable folk in France (excepting M. Horace Vernet) hate the Frenchman. It is not ideas that this restless people wants, but facts, historical reports, topical rhymes, and *Le Moniteur*.[2] That is all: abstractions, never! The Frenchman has done great things, but almost by mistake. He has been *caused* to do them.

M. Horace Vernet[3] is a soldier who practices painting. Now I hate an art which is improvised to the roll of

the drum, I hate canvases splashed over at the gallop, I hate painting manufactured to the sound of pistol shots, since I hate the army, the police force—everything, in fact, that trails its noisy arms in a peaceful place. This immense popularity—which, however, will endure no longer than war itself, and will decline in proportion as the peoples of the world contrive other joys for themselves—this popularity, do I call it?—this *vox populi, vox Dei* for me is like a physical oppression.

I hate this man because his pictures have nothing whatever to do with painting (I would prefer to call them a kind of brisk and frequent masturbation in paint, a kind of itching on the French skin), just as I hate another such great man,[4] whose solemn hypocrisy has given him dreams of the consulate, and who has repaid the people's love with nothing more substantial than bad verses—verses which have nothing to do with poetry, but are ruptured and ill-composed, full of barbarities and solecisms, but also of civic virtue and patriotism.

I hate him because he was born under a lucky star,[5] and because for him art is a simple and easy matter. Nevertheless he is the chronicler of your National glory, and that is the great thing. But what, I ask you, can that matter to the enthusiastic traveler, to the cosmopolitan spirit who prefers beauty to glory?

To define M. Horace Vernet as clearly as possible, he is the absolute antithesis of the artist: he substitutes *chic* for drawing, cacophony for color, and episodes for unity; he paints Meissoniers as big as houses.

Furthermore, in order to fulfill his official mission, M. Horace Vernet is gifted with two outstanding qualities—the one of deficiency, the other of excess; for he lacks all passion, and has a memory like an almanac![6] Who knows better than he the correct number of buttons on each uniform, or the anatomy of a gaiter or a boot which is the worse for innumerable days' marching, or the exact spot on a soldier's gear where the copper of his small arms deposits its verdigris? Therefore what a vast public he has, and what bliss he affords them! He has, in fact, as many different publics as it takes trades to manufacture uniforms, shakos, swords, muskets, and cannons! Imagine all those honorable guilds mustered in a front of a Horace Vernet by their common love of glory! What a sight!

One day I remember twitting some Germans with their taste for Scribe[7] and Horace Vernet. They answered, "We have a deep admiration for Horace Vernet as being the most complete representative of his age." Well said!

The tale is told that one day M. Horace Vernet went to see Peter Cornelius.[8] He overwhelmed him with compliments, but had to wait a long time to be repaid; for Peter Cornelius congratulated him only once during the whole interview—and that was on the quantity of champagne that he was able to consume without suffering ill effects! True or false, the story has all the ring of poetic truth.

And now tell me again that the Germans are a simple-minded people!

Many people who believe in the oblique approach when it comes to a critical drubbing, and who have no more love than I for M. Horace Vernet, will blame me for being clumsy in my attack. But there can be no imprudence in being brutal and going straight to the point when in every sentence the "I" stands for a "we"—a vast, but silent and invisible "we," a whole new generation which hates war and national follies; "we," a generation full of health because it is young, a generation which is already elbowing its way to the front and working up into a good position—serious, derisive, and menacing![9]

MM. Granet and Alfred Dedreux are two more vignette-makers and great adorers of the "chic." But they apply their capacities of improvisation to very different genres—M. Granet[10] to the sphere of religion, and M. Dedreux[11] to that of smart life. The first does monks, and the second horses; the first is dark in color, the second is bright and dazzling. M. Alfred Dedreux has two excellent qualities; he knows how to paint, and his works have the fresh and vivid appearance of theatrical decors. One would suppose that he is more concerned with nature in those subjects which form his specialty; for his studies of running hounds are more convincing and more solid than the rest. There is a touch of the comic however, in his hunting scenes; each one of those all-important hounds could gobble up four horses. They remind one of those famous sheep in Jouvenet's *Vendeurs du Temple*,[12] which quite swamp the figure of Christ.

As you see, we are now in the hospital of painting. We are probing its sores and its sicknesses; and this is by no means among the least strange or contagious of them.

In the present age, just as in ages past, today no less than yesterday, the strong and vigorous divide between them the various territories of art, each according to his tastes and his temperament, and there they labor in full freedom, following the fatal law of propensities. Some gather an easy and abundant harvest in the golden, autumnal vineyards of color; others toil patiently and laboriously to drive the deep furrow of drawing. Each of these men knows quite well that his monarchy involves a sacrifice, and that it is on this condition alone that he can reign securely up to his limiting frontiers. Each of them has a banner to his crown, and the words inscribed upon that banner are clear for all the world to read. Not one of their number has doubts of his monarchy, and it is in this unshakable conviction that their serene glory resides.

M. Horace Vernet himself, that odious representative of the "chic," has at least the merit of not being a *doubter*. He is a man of a happy and playful disposition, who inhabits an artificial country where the actors and the scenery are all made of the same pasteboard; yet he reigns as master in his kingdom of pantomime and parade.

Doubt, which today is the principal cause of all morbid affections in the moral world, and whose ravages are

now greater than ever before, is itself dependent upon higher causes which I shall analyze in my penultimate chapter, entitled "On Schools and Journeyman." And Doubt begat Eclecticism; for the doubters had a genuine will for salvation.

Eclecticism has at all periods and places held itself superior to past doctrines, because, coming last on to the scene, it finds the remotest horizons already open to it; but this *impartiality* only goes to prove the impotence of the eclectics. People who are so lavish with their time for reflection are not complete men: they lack the element of passion.

It has never occurred to the eclectics that man's attention is the more intense as it is restricted and limits its own field of observation. It is a question of grasp all, lose all.

It is in the arts, above all, that eclecticism has had the most manifest and palpable consequences, because if art is to be profound, it must aim at constant idealization, which is not to be achieved except in virtue of sacrifice—an involuntary sacrifice.

No matter how clever he may be, an eclectic is but a feeble man; for he is a man without love. Therefore he has no ideal, no *parti pris*; neither star nor compass. He mixes four different systems, which only results in an effect of darkness—a negation.

An eclectic is a ship which tries to sail before all four winds at once.

However great its defects, a work conceived from an

exclusive point of view will always have a great attraction for temperaments analogous to that of the artist.

An eclectic's work leaves no memory behind it.

The eclectic does not know that the first business of an artist is to protest against Nature by putting Man in her place. This protest is not made coldly and calculatedly, like a decree or a rhetorical exercise; it is spontaneous and urgent, like vice, passion, or appetite. Thus an eclectic is no man.

Doubt has led certain artists to beg the aid of all the other arts. Experiment with contradictory means, the encroachment of one art upon another, the importation of poetry, wit, and sentiment into painting—all these modern miseries are vices peculiar to the eclectics.

XIII. ON M. ARY SCHEFFER AND THE APES OF SENTIMENT

M. Ary Scheffer is a disastrous example of this method—if an absence of method can so be called.

After imitating Delacroix, after aping the colorists and draftsmen of the French school, and the neo-Christian school of Overbeck,[1] it dawned upon M. Ary Scheffer—a little late, no doubt—that he was not a painter born. From that moment he was obliged to turn to other shifts; and he decided to ask help and protection from poetry.

It was a ridiculous blunder, for two reasons. First of all, poetry is not the painter's immediate aim: when poetry happens to be mixed with painting, the resulting work cannot but be more valuable; but poetry is unable to disguise the shortcomings of a work. To make a deliberate point of looking for poetry during the conception of a picture is the surest means of not finding it. It must come without the artist's knowledge. It is the result of the art of painting itself; for it lies in the spectator's soul, and it is the mark of genius to awaken it there. Painting is only interesting in virtue of color and form; it is no more like poetry than poetry is like painting—than the extent, I mean, to which poetry is able to awaken ideas of painting in the reader.

In the second place—and this is a consequence of these last observations—it should be noticed that great artists, whose instinct always guides them aright, have taken only the most highly colored and clearly visual

subjects from the poets. Thus they prefer Shakespeare to Ariosto.

And now, to choose a striking example of M. Ary Scheffer's ineptitude, let us examine the subject of his painting entitled *St. Augustine and St. Monica*.[2] An honest painter of the Spanish School, with his double piety—artistic and religious—would simply and sincerely have done his best to paint the general idea which he had formed of the two saints. But put all that out of your mind; here the vital thing is to express the following passage—with brushes and color: "We did betwixt ourselves seek at that Present Truth (which Thou art) in what manner the eternal life of the saints was to be, which eye hath not seen, nor ear heard, nor hath it entered into the heart of man."[3] It is the very height of absurdity. It is like watching a dancer execute a mathematical figure!

Formerly M. Ary Scheffer enjoyed the public's favor; in his *poetical* pictures, people rediscovered their dearest memories of the great poets—and that was enough for them. The transient vogue for M. Ary Scheffer was in fact a homage to the memory of Goethe.[4] But our artists—even those of them who are only gifted with a moderate originality—have for a long time been showing the public samples of real painting, executed with a sure hand and according to the simplest rules of art. And so, little by little the public has grown sick of *invisible* painting, and today, where M. Ary Scheffer is concerned, its favor has turned to harshness and ingratitude. How like all publics! But upon my word, they are quite right!

Moreover this kind of painting is so wretched, so dismal, so blurred, and so muddy that many people have taken M. Ary Scheffer's pictures for those of M. Henri Scheffer,[5] another artistic Girondist. In my opinion, they are more like pictures by M. Delaroche which have been left out in a heavy rainstorm.

A simple method of learning an artist's range is to examine his public. Eugène Delacroix has the painters and the poets on his side; M. Decamps has the painters; M. Horace Vernet has the garrisons; and M. Ary Scheffer those aesthetic ladies who revenge themselves on the curse of their sex by indulging in religious music.[6]

The apes of sentiment are, generally speaking, bad artists. If it were otherwise, they would do something other than sentimentalize. The best of them are those whose understanding does not go beyond the *pretty*.

As feeling or sentiment, like fashion, is an infinitely variable and multiple thing, there are apes of sentiment of different orders.

The ape of sentiment relies above all on the catalogue. It should be noted, however, that the picture's title never tells its subject—and this is particularly true with those artists who, by an engaging fusion of horrors, mix sentiment with wit. In this way, by extending the method, it will be possible to achieve the *sentimental rebus*.[7]

For example, you find in the catalogue something called *Pauvre Fileuse!*[8] Well, it is quite possible that the picture may represent a female silkworm, or a caterpillar, squashed by a child. This is an age without pity!

Aujourd'hui and *Demain*.[9] What can that be? Perhaps a white flag—and a tricolor? Or perhaps a deputy in his moment of triumph—and the same deputy after being sent packing? But no; it is a young maiden, promoted to the status of street-walker, playing with roses and jewels; and then the same girl, crippled and emaciated, suffering the consequences of her indiscretions in the gutter.

L'Indiscret.[10] I beg of you to look for this one. It represents a gentleman surprising a couple of blushing damsels with a naughty picture book. This picture comes into the Louis xv class of sentimental genre, which began, I believe, to slip into the Salon in the wake of *La Permission de dix heures*.[11] Quite a different order of sentiments is involved, here as you can see; these ones are less *mystical*.

In general, sentimental genre pictures are taken from the latest poems of some bluestocking or other— that is the melancholy and misty kind; or else they are a pictorial translation of the outcries of the poor against the rich—the protesting kind; or else they are borrowed from the wisdom of the nations—the witty kind; and sometimes from the works of M. Bouilly[12] or of Bernardin de Saint-Pierre[13]—the moralizing kind.

Here are a few more examples of the same genre: *L'Amour à la ville*[14]—shouts, disorder, upturned chairs and books. It is a metaphysic within the reach of the simple.

La Vie d'une jeune fille en quatre compartiments.[15] A warning to those who have a bent for motherhood!

L'Aumône d'une vierge folle.[16] The crazed old creature is giving a copper, earned by the sweat of her brow, to the beggar who mounts eternal guard at the door of Félix, the pastry cook.[17] Inside, the rich of the day are gorging themselves on sweetmeats. This one evidently derives from literature of the *Marion Delorme*[18] persuasion, which consists of preaching the virtues of whores and assassins.

How witty the French are, and what pains they take in order to delude themselves! Books, pictures, drawing-room ballads, nothing is without its use, no means is neglected by this charming people when it is a question of throwing dust in their own eyes.

Doubt assumes a whole host of forms; it is a Proteus which often does not recognize its own face. And so there is infinite variety among doubters, and I am obliged now to bundle together several individuals who have nothing in common beyond the absence of any substantial individuality.

Some of them are serious-minded and full of great goodwill. These ones deserve our pity.

There is M. Papety, for instance, who at the time of his return from Rome was regarded as a colorist by some people (chiefly his friends). This year he has sent a picture entitled *Solon dictant ses lois*,[1] which is shockingly unpleasant to look at. Perhaps it is because it hangs too high for its details to be properly visible, that it reminds one of the ridiculous tail end of the Imperial School.

For two years running now M. Papety has sent entirely different-looking pictures to the same Salon.

M. Glaize is compromising his early success by giving us works both vulgar in style and muddled in composition. Every time that he has to do anything else but a study of a woman, he gets lost. M. Glaize believes that you become a colorist by the exclusive choice of certain hues. Window-dressers' assistants and theatrical costumiers, too, have a taste for rich hues; but that does not make a taste for harmony.

In *Le Sang de Vénus*,[2] Venus is a pretty and delicate figure, with good suggestion of movement; but the nymph who crouches in front of her is an appalling example of the "poncif."

M. Matout is liable to the same criticism on the score of color. Furthermore, an artist who formerly took his bow as a draftsman, and who used to devote his mind above all to the compound harmony of lines, should avoid giving a figure improbable movements of the neck and arm. Even if nature demands it, the artist who is an idealist, and who wishes to be true to his principles, should not comply.

M. Chenavard is an eminently learned and hardworking artist, whose *Martyre de St. Polycarpe*, painted in collaboration with M. Comairas, attracted attention several years ago. This picture bespoke a real grasp of the science of composition and a thorough connoisseurship of all the Italian masters. This year M. Chenavard has given further proof of taste in his choice of subject, and of cleverness in his drawing.[3] But when you are contending with Michelangelo, would it not be fitting to outdo him in *color*, at least?

M. Guignet always carries two men about in his head—Salvator Rosa and M. Decamps. M. Salvator Guignet paints in sepia; M. Guignet Decamps is an entity weakened by duality. *Les Condottières après un pillage*[4] is painted in the first manner; *Xerxès* verges upon the second. Nevertheless this picture is well enough composed,

were it not for a taste for erudition and connoisseurship, which amuses and fascinates the spectator, and deflects his attention from the principal idea; the same thing was wrong with his *Pharaons*.[5]

MM. Brune and Gigoux are already established names. But even at his best period, M. Gigoux hardly produced anything more than vast vignettes. After numerous setbacks, he has at last shown us a picture which, if not very original, is at least quite well *built*. *Le Mariage de la Sainte Vierge* looks like a work by one of those countless masters of the Florentine decadence, supposing him to have become suddenly preoccupied with color. M. Brune puts one in mind of the Carracci and the eclectic painters of the second epoch; a solid manner, but little or no soul—no great faults, but no great quality.

If there are some doubters who excite interest, there are also some grotesque ones, whom the public meets again each year with that wicked delight characteristic of bored *flâneurs* for whom excessive ugliness always secures a few moments' distraction.

The coldly frivolous M. Bard seems to be really and truly succumbing beneath the burden which he has imposed upon himself. He returns from time to time, however, to his natural manner—which is the same as everybody else's. I have been told that the author of *La Barque de Caron* was a pupil of M. Horace Vernet.

M. Biard[6] is a universal man. This would seem to indicate that he has not the least doubt in the world, and that no one on earth is surer of his ground. Nevertheless

I ask you to observe that amid all this appalling lumber—history pictures, travel pictures, sentimental pictures, epigrammatic pictures—one genre is neglected. M. Biard has flinched before the religious picture. He is not yet sufficiently convinced of his powers.

In landscape, as in portraiture and history painting, it is possible to establish classifications based on the different methods used; thus there are landscape colorists, landscape draftsmen, and imaginative landscapists; there are naturalists who idealize without knowing it, and partisans of the "poncif," who devote themselves to a weird and peculiar genre called *historical* landscape.

At the time of the romantic revolution, the landscape painters, following the example of the most celebrated Flemish masters, devoted themselves exclusively to the study of nature; it was this that was their salvation and gave a particular luster to the modern school of landscape. The essence of their talent lay in an eternal adoration of visible creation, under all its aspects and in all its details.

Others, more philosophic and more dialectical, concentrated chiefly on style—that is to say, on the harmony of the principal lines, and on the architecture of nature.

As for the landscape of fantasy, which is the expression of man's dreaming, or the egoism of man substituted for nature, it was little cultivated. This curious genre, of which the best examples are offered by Rembrandt, Rubens, Watteau, and a handful of English illustrated annuals, and which is itself a small-scale counterpart of the magnificent stage decors at the Opera, represents our natural need for the marvelous. It is the "graphic imagination" imported into landscape. Fabu-

lous gardens, limitless horizons, streams more limpid than in nature, and flowing in defiance of the laws of topography, gigantic boulders constructed according to ideal proportions, mists floating like a dream—the landscape of fantasy, in short, has had but few enthusiastic followers among us, either because it was a somewhat un-French fruit, or because our school of landscape needed before all else to reinvigorate itself at purely natural springs.

As for historical landscape, over which I want to say a few words in the manner of a requiem-mass, it is neither free fantasy, nor has it any connection with the admirable slavishness of the naturalists; it is ethics applied to nature.

What a contradiction, and what a monstrosity! Nature has no other ethics but the brute facts, because Nature is her own ethics; nevertheless we are asked to believe that she must be reconstructed and set in order according to sounder and purer rules—rules which are not to be found in simple enthusiasm for the ideal, but in esoteric codes which the adepts reveal to no one.

Thus, Tragedy—that genre forgotten of men, of which it is only at the Comédie Française (the most deserted theater in the universe) that one can find a few samples[1]—the art of Tragedy, I say, consists in cutting out certain eternal patterns (for example, patterns of love, hate, filial piety, ambition, etc.), and after suspending them on wires, in making them walk, bow, sit down, and speak, according to a sacred and mysterious

ceremonial. Never, even by dint of using mallet and wedge, will you cause an idea of the infinite degrees of variety to penetrate the skull of a tragic poet, and even if you beat or kill him, you will not persuade him that there must be different sorts of morality too. Have you ever seen tragic persons eat or drink? It is obvious that these people have invented their own moral system to fit their natural needs, and that they have created their own temperament, whereas the majority of mankind have to *submit* to theirs. I once heard a poet-in-ordinary to the Comédie Française say that Balzac's novels wrung his heart with pain and disgust; that, as far as he was concerned, he could not conceive of lovers existing on anything else but the scent of flowers and the teardrops of the dawn. It seems to me that it is time the government took a hand; for if men of letters, who each have their own labors and their own dreams, and for whom there is no such thing as Sunday—if men of letters can escape the risk of tragedy quite naturally, there are nevertheless a certain number of people who have been persuaded that the Comédie Française is the sanctuary of art, and whose admirable goodwill is cheated one day in every seven. Is it reasonable to allow some of our citizens to besot themselves and to contract false ideas? But it seems that tragedy and historical landscape are stronger than the gods themselves.

So now you understand what is meant by a good tragic landscape. It is an arrangement of master patterns of trees, fountains, tombs, and funerary urns. The dogs

are cut out on some sort of historical dog pattern; a historical shepherd could never allow himself any others, on pain of disgrace. Every *immoral* tree that has allowed itself to grow up on its own, and in its own way, is, of necessity, cut down: every toad or tadpole pond is pitilessly buried beneath the earth. And if ever a historical-landscape painter feels remorse for some natural peccadillo or other, he imagines his Hell in the guise of a *real* landscape, a pure sky, a free and rich vegetation; a savannah, for example, or a virgin forest.

MM. Paul Flandrin, Desgoffe, Chevandier, and Teytaud are the men who have undertaken the glorious task of struggling against the taste of a nation.

I do not know what is the origin of historical landscape. It certainly cannot have sprung from Poussin, for in comparison with these gentlemen, he is a depraved and perverted spirit.

MM. Aligny, Corot, and Cabat are much concerned with style. But what, with M. Aligny, is a violent and philosophic dogma, is instinctive habit and a natural turn of mind with M. Corot. Unfortunately he has only sent one landscape this year; it represents cows coming to drink at a pool in the forest of Fontainebleau.[2] M. Corot is a harmonist rather than a colorist; and it is their very simplicity of color, combined with their complete lack of pedantry, that gives such enchantment to his compositions. Almost all his works have the particular gift of unity, which is one of the requirements of the memory.

M. Aligny has etched some very beautiful views of Corinth and Athens which perfectly express the preconceived idea of these places. M. Aligny's serious and idealistic talent has found a most suitable subject in these harmonious poems of stone, and his method of translating them on to copper suits him no less well.[3]

M. Cabat has completely deserted the path on which he had won himself such a great reputation. Without ever being a party to the *bravura* peculiar to certain naturalistic landscape painters, he was formerly very much more brilliant and very much more *naïf*. He is truly mistaken in no longer putting his trust in nature, as he used to do. He is a man whose talent is too great for any of his compositions to lack a special distinction; but this latter-day Jansenism, this retrenchment of means, this deliberate self-privation cannot add to his glory.[4]

In general the influence of Ingrism cannot possibly produce satisfactory results in landscape. Line and style are no substitutes for light, shadow, reflections, and the *coloring* atmosphere—all of which play too great a part in the poetry of Nature to allow her to submit to this method.

The members of the opposite party, the naturalists and the colorists, are much more popular and have made much more of a mark. Their main qualities are a rich and abundant color, transparent and luminous skies, and a special kind of sincerity which makes them accept everything that nature gives. It is a pity that some of them, like M. Troyon,[5] take too much delight in the

tightrope tricks of their brush; these devices, known in advance, acquired with much trouble, and monotonously triumphant, sometimes intrigue the spectator more than the landscape itself. In these circumstances, it may even happen that a surprise pupil, like M. Charles Le Roux,[6] will push still further the limits of boldness and security; for there is only one inimitable thing, and that is natural simplicity.

M. Coignard has sent a large and fairly well-constructed landscape which has much attracted the public eye; it has a number of cows in the foreground, and in the background the skirts of a forest. The cows are beautiful and well painted, and the picture looks well as a whole; but I do not think that the trees are vigorous enough to support such a sky. This suggests that if you took away the cows, the landscape would become very unsightly.

M. Français is one of our most distinguished landscape painters. He knows how to study nature, and how to blend with it a romantic perfume of the purest essence. His *Etude de Saint-Cloud* is a charming thing and full of taste, except for M. Meissonier's *fleas* which are a fault of taste.[7] They attract the attention too much, and they amuse the blockheads. Nevertheless they are done with that particular sort of perfection which this artist puts into all his little things.[8]

Unfortunately M. Flers has only sent pastels. His own loss is equal to that of the public.

M. Héroult is one of those who are particularly obsessed with light and atmosphere. He is very good at

rendering clear, smiling skies, and floating mists shot through with a ray of sunlight. He is no stranger to the special poetry of the northern countries. But his color, which is little too soft and fluid, smacks of the methods of watercolor; and he has been able to avoid the heroics of the other landscape painters; he does not always possess a sufficient firmness of touch.

As a rule MM. Joyant, Chacaton, Lottier, and Borget go to distant lands in search of their subjects, and their pictures have the charm of an evening with a travel book.

I have nothing against specialization; but I would not have anyone abuse it to the extent of M. Joyant, who has never set foot outside the Piazza San Marco and has never crossed to the Lido.[9] If M. Joyant's specialty attracts the eye more than the next man's, it is doubtless because of the monotonous perfection which he brings to it and which results always from the same tricks. It seems to me that M. Joyant has never been able to move onward.

M. Borget, however, has crossed the frontiers of China, and has brought us landscapes from Mexico, Peru, and India. Without being a painter of the first rank, he has brilliant and fluent color, and his tones are fresh and pure. With a little less art, and if he could concern himself less with other landscape painters and could paint more as a simple traveler, M. Borget would perhaps obtain more interesting results.

M. Chacaton, who has devoted himself exclusively to the Orient, has for a long time been one of our cleverest painters. His pictures are bright and smiling. Unfortu-

nately they almost always suggest paintings by Decamps or Marilhat, bleached, and reduced in size.

M. Lottier, instead of looking for the gray and misty effects of the warm climates, loves to bring out their harshness and their fiery dazzle. The truth of these sun-swamped panoramas is marvelously brutal. You would think that they had been done with a color-daguerreotype.

There is one man who, more than all of these, and more even than the most celebrated absentees, seems to me to fulfill the conditions of beauty in landscape: he is a man but little known to the multitude, for past setbacks and underhand plotting have combined together to keep him away from the Salon. You will already have guessed that I am referring to M. Rousseau[10]—and it seems to me to be high time that he took his bow once again before a public which, thanks to the efforts of other painters, has gradually become familiar with new aspects of landscape.

It is as difficult to interpret M. Rousseau's talent in words as it is to interpret that of Delacroix, with whom he has other affinities also. M. Rousseau is a northern landscape painter. His painting breathes a great sigh of melancholy. He loves nature in her *bluish* moments—twilight effects—strange and moisture-laden sunsets—massive, breeze-haunted shades—great plays of light and shadow. His color is magnificent, but not dazzling. The fleecy softness of his skies is incomparable. Think of certain landscapes by Rubens and Rembrandt; add a few memories of English painting, and assume a deep and

serious love of nature dominating and ordering it all—
and then perhaps you will be able to form some idea of
the magic of his pictures. Like Delacroix, he adds much
of his soul to the mixture; he is a naturalist, ceaselessly
swept toward the ideal.

M. Gudin[11] is increasingly compromising his reputa-
tion. The more the public sees good painting, the more
it parts company from even the most popular artists if
they cannot offer it the same amount of pleasure. For me,
M. Gudin comes into the class of people who stop their
wounds with artificial flesh; of bad singers of whom it
is said that they are great actors; and of *poetic* painters.

M. Jules Noël has produced a really beautiful marine
painting, of a fine, clear color, bright and luminous.[12]
A huge *felucca*, with its strange shapes and colors, is
lying at anchor in some great harbor, bathed in all the
shifting light of the Orient. A little too much *coloring*,
perhaps, and not enough unity? But M. Jules Noël cer-
tainly has too much talent not to have still more, and he
is doubtless one of those who impose a daily amount of
progress upon themselves.—Furthermore the success
achieved by this canvas proves that the public of today
is ready to extend a warm welcome to all newcomers, in
all the genres.

M. Kiorboë is one of those sumptuous painters of
old who knew so well how to decorate their noble din-
ing rooms, which one imagines full of heroic and rav-

enous huntsmen. M. Kiorboë's painting has joyfulness and power, and his color is fluent and harmonious. The drama of his *Wolf-Trap*,[13] however, is not quite easy enough to follow, perhaps because the trap itself is partly in the shadow. The hindquarters of the dog which are falling back with a yelp are not vigorously enough painted.

M. Saint-Jean,[14] who, I am told, is the delight and the glory of the city of Lyons, will never achieve more than a moderate success in a country of painters. That excessive minuteness of his is intolerably pedantic. Whenever anyone talks to you of the *naïveté* of a painter from Lyons, do not believe a word of it. For a long time now the overall color of M. Saint-Jean's pictures has been the yellow of urine. You might imagine that he had never seen real fruit, and that he does not care a scrap, because he can do them very nicely by mechanical means. Not only do natural fruits look quite different, but they are less finished and less highly wrought than these.

It is quite a different matter with M. Arondel, whose chief merit is a real artlessness. Therefore his painting contains several obvious blemishes; but the felicitous passages are entirely successful. Some other parts are too dark, and you might suppose that, while painting, this artist fails to take into account all the necessary accidents of the Salon—the adjacent paintings, the distance from the spectator, and the modification which distance causes in the mutual effect of tones. Besides, it is not enough to paint well. The famous Flemish painters all knew how to dispose of their dead game and how to go

on worrying at it for ages, just as one worries at a model; the point was to discover felicitous lines, and rich and dear tonal harmonies.

M. P. Rousseau, whose dazzling and colorful pictures have received such widespread notice, is making serious progress. He was already an excellent painter, it is true; but now he is looking at nature more attentively and he is striving to bring out her particularity of feature.[15] The other day at Durand-Ruel's[16] I saw some ducks by M. Rousseau; they were wonderfully beautiful, and really behaved and acted like ducks.

The origin of sculpture is lost in the mists of time; thus it is a *Carib* art.

We find, in fact, that all races bring real skill to the carving of fetishes long before they embark upon the art of painting, which is an art involving profound thought and one whose very enjoyment demands a particular initiation.

Sculpture comes much closer to nature, and that that is why even today our peasants, who are enchanted by the sight of an ingeniously turned fragment of wood or stone, will nevertheless remain unmoved in front of the most beautiful painting. Here we have a singular mystery which is quite beyond human solving.

Sculpture has several disadvantages which are a necessary consequence of its means and materials. Though as brutal and positive as nature herself, it has at the same time a certain vagueness and ambiguity, because it exhibits too many surfaces at once. It is in vain that the sculptor forces himself to take up a unique point of view, for the spectator who moves around the figure can choose a hundred different points of view, except for the right one, and it often happens that a chance trick of the light, an effect of the lamp, may discover a beauty which is not at all the one the artist had in mind—and this is a humiliating thing for him. A picture, however, is only what it means to be; there is no other way of looking at it than on its own terms. Painting has but one point

of view; it is exclusive and absolute, and therefore the painter's expression is much more forceful.

That is why it is as difficult to be a connoisseur of sculpture as it is to be a bad sculptor. I have heard the sculptor Préault[1] say, "I am a connoisseur of Michelangelo, of Jean Goujon, of Germain Pilon; but of sculpture I am a complete ignoramus." It is obvious that he meant the *sculpture* of the sculpturizers—in other words, of the Caribs.

Once out of the primitive era, sculpture, in its most magnificent development, is nothing else but a *complementary* art. It is no longer a question of skillfully carving portable figures, but of becoming a humble associate of painting and architecture, and of serving their intentions. Cathedrals soar up into the sky and load their thousand echoing chasms with sculptures, which form but one flesh and body with the edifice itself: please note that I am speaking of *painted* sculptures, whose pure and simple colors, arranged in accordance with a special scale, harmonize with the rest and complete the poetic effect of the whole. Versailles shelters her race of statues beneath leafy shades which serve them as background, or under arbors of living waters which shower upon them the thousand diamonds of the light. At all great periods, sculpture is a complement; at the beginning and at the end, it is an isolated art.

As soon as sculpture consents to be seen close at hand, there are no childish trivialities which the sculptor will not dare, and which triumphantly outrun the

fetish and the calumet. When it has become a draw-
ing room or a bedroom art, it is the cue for the Caribs
of lace (like M. Gayrard), or for the Caribs of the wrin-
kle, the hair, and the wart (like M. David[2]) to put in an
appearance.

Next we have the Caribs of the andiron, the clock, and
the writing desk, etc., like M. Cumberworth, whose *Ma-
rie* is a maid-of-all-work: employed at the Louvre and at
Susse's, as a statue or a candelabra;[3] or like M. Feuchère,
who possesses the gift of a universality which takes
one's breath away; colossal figures, matchboxes, gold-
smiths' motifs, busts, and bas-reliefs—he is capable
of anything. The bust which he has done this year of a
very well-known actor[4] is no better a likeness than last
year's; they are never more than rough approximations.
Last year's bust resembled Jesus Christ, and this year's,
which is dry and mean-looking, in no way conveys the
original, angular, sardonic, and shifting physiognomy
of the model. Nevertheless you should not suppose that
these people lack knowledge. They are as learned as
academicians—or as *vaudevillistes*; they make free with
all periods and all genres; they have plumbed the depth
of all the schools. They would he happy to convert even
the tombs of St. Denis into cigar or shawl boxes, and
every Florentine bronze into a threepenny bit. If you
want the fullest information concerning the principles
of this frivolous and trifling school, you should apply to
M. Klagmann,[5] who is, I think, the master of this whole
vast workshop.

An excellent proof of the pitiable state of sculpture to-day is the fact that M. Pradier[6] is its king. Admittedly this artist knows how to do flesh, and he has his particular refinements of the chisel; but he has neither the imagination necessary for great compositions, nor the "graphic imagination." His talent is cold and academic. He has spent his life fattening up a small stock of antique torsos and equipping them with the coiffeurs of kept women. His *Poésie Légère*[7] seems all the colder as it is the more mannered; its execution is not as opulent as in the sculptor's former works, and, seen from behind, it looks hideous. Besides this, he has done two bronzes—*Anacréon* and *La Sagesse*—which are impudent imitations of the antique and show clearly that without this noble crutch M. Pradier would stumble at every step.

The bust is a genre which demands less imagination and capacities less lofty—though no less delicate—than sculpture on the grand scale. It is a more intimate and more restricted art, whose successes are less public. As in the portrait done according to the manner of the naturalists, it is necessary to have a perfect grasp of the model's essential nature, and to express its poetic quality; for there are few models who completely lack poetry. Almost all of M. Dantan's busts[8] are done according to the best doctrines. They all have a particular distinction, and their detail does not exclude breadth and ease of execution.

M. Lenglet's chief fault,[9] on the contrary, is a certain timidity, a childishness, an excess of sincerity in his exe-

cution, which gives an appearance of dryness to his work; but, on the other hand, no one could give a truer and more authentic character to a human face. This little bust—stocky, grave, and frowning—has the magnificent character of the best work of the Romans—an idealization discovered in nature herself. Another distinguishing quality of antique portraiture which I noticed in M. Lenglet's bust is a profound concentration of attention.

If ever your idler's curiosity has landed you in a street brawl, perhaps you will have felt the same delight as I have often felt to see a protector of the public slumbers—a policeman or a municipal guard (the real army)—thumping a republican. And if so, like me, you will have said in your heart: "Thump on, thump a little harder, thump again, beloved constable! For at this supreme thumping, I adore thee and judge thee the equal of Jupiter, the great dealer of justice! The man whom thou thumpest is an enemy of roses and of perfumes, and a maniac for *utensils*. He is the enemy of Watteau, the enemy of Raphael, the bitter enemy of luxury, of the fine arts and of literature, a sworn iconoclast and butcher of Venus and Apollo! He is no longer willing to help with the public roses and perfumes, as a humble and anonymous journeyman. He wants to be *free*, poor fool; but he is incapable of founding a factory for *new* flowers and *new* scents. Thump him devoutly across the shoulder blades, the anarchist!"[1]

In the same way philosophers and critics should pitilessly thump *artistic* apes—emancipated journeymen who hate the force and the sovereignty of genius.

Compare the present age with past ages. On leaving the Salon or some newly decorated church, go and rest your eyes in a museum of old masters. And then analyze the differences.

In the one, all is turbulence, a hurly-burly of styles

and colors, a cacophony of tones, enormous trivialities, platitudes of gesture and pose, nobility "by numbers," clichés of all kinds—and all this clearly manifested not only by different pictures in juxtaposition, but even within one and the same picture. In short, there is a complete absence of unity, whose only result is a terrible weariness for the mind and the eyes.

In the other place you are immediately struck by that feeling of reverence which causes children to doff their hats and which catches at your soul in the way that the dust of vaults and tombs catches your throat. But this is by no means the mere effect of yellow varnish or the grime of ages: it is the effect of unity, of profound unity. For a great Venetian painting clashes less with a Giulio Romano beside it than a group of our pictures—and I do not mean the worst of them—clash among themselves.

A magnificence of costume, a nobility of movement— a nobility often mannered, yet grand and stately—and an absence of little tricks and contradictory tactics—these are qualities which are all implied in the phrase "the great tradition."

Then you had schools of painting; *now* you have emancipated journeyman.

There were still schools under Louis XV; there was one under the Empire—a school—that is, a faith—that is, the impossibility of doubt. There you had pupils united by common principles, obedient to the rule of a powerful leader, and helping him in all his undertakings.

Doubt, or the absence of faith and of *naïveté*, is a vice

peculiar to this age, for today no one is obedient, and *naïveté*, which means the dominion of temperament within manner, is a divine privilege which almost all are without.

Few men have a right to rule, for few men have an overruling passion. And as everyone today wants to rule, no one knows how to govern himself.

Now that everyone is abandoned to his own devices, a master has many unknown pupils for whom he is not responsible, and his blind and involuntary dominion extends well beyond his studio, as far as regions where his thought cannot be understood.

Those who are nearer to the word and the idiom of the master preserve the purity of his doctrine, and by obedience and tradition they do what the master does by the fatality of his nature.

But outside of this family circle there is a vast population of mediocrities—apes of different and mixed breeds, a floating race of half-castes who each day move from one country to another, taking away from each the customs which suit them, and seeking to make a personality for themselves by a system of contradictory borrowings.

There are people who will steal a fragment from a picture by Rembrandt, and without modifying it, without digesting it, without even finding the glue to stick it on with, will incorporate it into a work composed from an entirely different point of view.

There are some who change from white to black in a day: yesterday, colorists in the "chic" manner, color-

ists with neither love nor originality—tomorrow, sacrilegious imitators of M. Ingres, but without discovering any more taste or faith.

The sort of man who today comes into the class of the apes—even the cleverest apes—is not, and never will be, anything but a mediocre painter. There was a time when he would have made an excellent journeyman: but now he is lost, for himself and for all mankind.

That is why it would have been more in the interest of their own salvation, and even of their happiness, if the lukewarm had been subjected to the lash of a vigorous faith. For strong men are rare, and today you have to be a Delacroix or an Ingres if you are to come to the surface and be seen amid the chaos of an exhausting and sterile freedom.

The apes are the republicans of art, and the present state of painting is the result of an anarchic freedom which glorifies the individual, however feeble he may be, to the detriment of communities—that is to say, of schools.

In schools, which are nothing else but organizations of inventive force, those individuals who are truly worthy of the name absorb the weak. And that is justice, for an abundant production is only a mind equipped with the power of a thousand arms.

This glorification of the individual has necessitated the infinite division of the territory of art. The absolute and divergent liberty of each man, the division of effort, and the disjunction of the human will have led to this

weakness, this doubt and this poverty of invention. A few sublime and long-suffering eccentrics are a poor compensation for this swarming chaos of mediocrity. Individuality—that little *place of one's own*—has devoured collective originality. And just as a well-known chapter of a romantic novel[2] has shown that the printed book has killed the monument of stone, so it is fair to say that, for the time being, it is the painter that has killed the art of painting.

Many people will attribute the present decadence in painting to our decadence in behavior.[1] This dogma of the studios, which has gained currency among the public, is a poor excuse of the artists. For they had a vested interest in ceaselessly depicting the past; it is an easier task, and one that could be turned to good account by the lazy.

It is true that the great tradition has been lost, and that the new one is not yet established.

But what *was* this great tradition, if not a habitual, everyday idealization of ancient life—a robust and martial form of life, a state of readiness on the part of each individual, which gave him a habit of gravity in his movements, and of majesty, or violence, in his attitudes? To this should be added a public splendor which found its reflection in private life. Ancient life was a great *parade*. It ministered above all to the pleasure of the eye, and this day-to-day paganism has marvelously served the arts.

Before trying to distinguish the epic side of modern life, and before bringing examples to prove that our age is no less fertile in sublime themes than past ages, we may assert that since all centuries and all peoples have had their own form of beauty, so inevitably we have ours. That is in the order of things.

All forms of beauty, like all possible phenomena, contain an element of the eternal and an element of the transitory—of the absolute and of the particular. Absolute and eternal beauty does not exist, or rather it is only

an abstraction skimmed from the general surface of different beauties. The particular element in each manifestation comes from the emotions: and just as we have our own particular emotions, so we have our own beauty.

Except for Hercules on Mount Oeta, Cato of Utica, and Cleopatra (whose suicides are not *modern* suicides[2]), what suicides do you find represented in the old masters? You will search in vain among pagan existences—existences dedicated to appetite—for the suicide of Jean-Jacques,[3] or even the weird and marvelous suicide of Rafael de Valentin.[4]

As for the garb, the outer husk, of the modern hero, although the time is past when every little artist dressed up as a grand panjandrum and smoked pipes as long as duck-rifles, nevertheless the studios and the world at large are still full of people who would like to poeticize *Antony* with a Greek cloak and a parti-colored vesture.[5]

But all the same, has not this much abused garb its own beauty and its native charm? Is it not the necessary garb of our suffering age, which wears the symbol of a perpetual mourning even upon its thin black shoulders? Note, too, that the dress coat and the frock coat not only possess their political beauty, which is an expression of universal equality, but also their poetic beauty, which is an expression of the public soul—an immense cortège of undertaker's mutes (mutes in love, political mutes, bourgeois mutes…). We are each of us celebrating some funeral.

A uniform livery of affliction bears witness to equal-

ity; and as for the eccentrics, whose violent and contrasting colors used easily to betray them to the eye, today they are satisfied with slight nuances in design in cut, much more than in color. Look at those grinning creases which play like serpents around mortified flesh—have they not their own mysterious grace?

Although M. Eugène Lami[6] and M. Gavarni[7] are not geniuses of the highest order, they have understood all this very well—the former, the poet of official dandyism, the latter the poet of a raffish and reach-me-down dandyism! The reader who turns again to M. Jules Barbey d'Aurevilly's book on Dandyism[8] will see clearly that it is a modern thing, resulting from causes entirely new.

Let not the tribe of colorists be too indignant. For if it is more difficult, their task is thereby only the more glorious. Great colorists know how to create color with a black coat, a white cravat, and a gray background.

But to return to our principal and essential problem, which is to discover whether we possess a specific beauty, intrinsic to our new emotions, I observe that the majority of artists who have attacked modern life have contented themselves with public and official subjects— with our victories and our political heroism. Even so, they do it with an ill grace, and only because they are commissioned by the government which pays them. However there are private subjects which are very much more heroic than these.

The pageant of fashionable life and the thousands of floating existences—criminals and kept women—which

drift about in the underworld of a great city; the *Gazette des Tribunaux* and the *Moniteur* all prove to us that we have only to open our eyes to recognize our heroism.

Suppose that a minister, baited by the opposition's impertinent questioning, has given expression once and for all—with that proud and sovereign eloquence which is proper to him—to his scorn and disgust for all ignorant and mischief-making oppositions. The same evening you will hear the following words buzzing round you on the Boulevard des Italiens: "Were you in the Chamber today? And did you see the minister? Good Heavens, how handsome he was! I have never seen such scorn!"

So there *are* such things as modern beauty and modern heroism!

And a little later—"I hear that K.—or F.—has been commissioned to do a medal on the subject; but he won't know how to do it—he has no understanding for these things."

So artists can be more, or less, fitted to understand modern beauty!

Or again: "The sublime rascal! Even Byron's pirates have less nobility and scorn. Would you believe it—he jostled the Abbé Montès aside, and literally *fell* upon the guillotine, shouting: 'Leave me my courage intact!'"

This last sentence alludes to the graveside braggadocio of a criminal—a great *protestant*, robust of body and mind, whose fierce courage was unabashed in the face of the very engine of death![9]

All these words that fall from your lips bear witness to your belief in a new and special beauty, which is neither that of Achilles nor yet of Agamemnon.

The life of our city is rich in poetic and marvelous subjects. We are enveloped and steeped as though in an atmosphere of the marvelous; but we do not notice it.

The *nude*—that darling of the artists, that necessary element of success—is just as frequent and necessary today as it was in the life of the ancients; in bed, for example, or in the bath, or in the anatomy theater. The themes and resources of painting are equally abundant and varied; but there is a new element—modern beauty.

For the heroes of the Iliad are but pygmies compared to you, Vautrin, Rastignac, and Birotteau![10]—and you, Fontanarès,[11] who dared not publicly declaim your sorrows in the funereal and tortured frock coat which we all wear today!—and you, Honoré de Balzac, you the most heroic, the most extraordinary, the most romantic, and the most poetic of all the characters that you have produced from your womb![12]

Notes

Charles Baudelaire's original notes are preceded by his initials. All notes otherwise are the translator's.

TO THE BOURGEOIS
1 I.e., the Republicans.

I

1 No. 4 of Gavarni's series of lithographs entitled *Leçons et Conseils*, published in *Le Charivari*, November 27, 1839.
2 CB I know quite well that criticism today has other pretensions; that is why it will always recommend drawing to colorists, and color to draftsmen. Its taste is in the highest degree rational and sublime!
3 CB With reference to the proper ordering of individualism, see the article on William Haussoullier, in the *Salon of 1845*. In spite of all the rebukes that I have suffered on this subject, I persist in my opinion; but it is necessary to understand the article.
4 *Histoire de la Peinture en Italie*, chap. 156 (edition of 1859, p. 338*n*2). Stendhal's phrase is "de la morale consruite," and he explains that he is using the past participle in the geometric sense.

II

1 A well-known archaeologist (1789–1854), who held several important positions and published many books on his subject.
2 CB Stendhal. (Translator's note: Baudelaire seems to have in mind a footnote in chap. 110 of the *Histoire de la Peinture en Italie*, where Stendhal wrote, "La beauté est l'expression d'une certaine maière habituelle de chercer le Bonheur ...")

III

1 CB Except for yellow and blue, its progenitors: but I am only speaking here of pure colors. For this rule cannot be applied to transcendent colorists who are thoroughly acquainted with the science of counterpoint.
2 CB Kreisleriana. (Translator's note: It is the third of the detached observations entitled *Höchst zerstreute Gedanken*.)

IV

1 Adolphe Thiers (1797–1877), later famous as statesman and historian, was at that time at the very outset of his career.
2 In the Louvre.

3 *L'imagination du dessin.*

4 According to Silvestre (*Histoire des artistes vivants*, 1856, p. 62), this was Gèrard.

5 Géricault is elsewhere recorded as saying that it was a picture that he would have been glad to have signed himself.

6 CB I write *pestiférés* instead of *massacres* in order to explain to the critics those flesh-tones to which they have so often and so stupidly objected. (Translator's note: The picture is now in the Louvre. It was painted in 1824.)

7 On which Delacroix was still engaged in 1846.

8 Painted in 1827. First exhibited the following year and now in the Bordeaux Museum.

9 Painted in 1827 and now in the Louvre.

10 Painted in 1830 and now in the Louvre.

11 On the Salon of 1824.

12 In 1832.

13 Painted in 1834 and now in the Louvre.

14 CB By the *naïvité* of the genius you must understand a complete knowledge of technique combined with the γνωθι σεαυτον of the Greeks, but with the knowledge modestly surrendering the leading role to temperament. (Translator's note: The word *naïvité*, used in this special sense, is one of the keywords of this *Salon*.)

15 Delacroix made six such lithographs in 1825.

16 The reference is to Carl Friedrich von Rumohr (1785–1843); his book, *Italienische Forschungen*, was published in three volumes between 1827 and 1831.

17 From Heine's Salon of 1831, which was published in a French translation in his *De la France*, 1833.

18 Ingres's *St. Symphorian* was commissioned for Autun cathedral in 1824; it was not completed until ten years later.

19 This is what M. Thiers called "l'imagination du dessin." See p. 40.

20 Baudelaire is mistaken here. Delacroix's *Pietà* was painted (in 1844) for the church of Saint-Denis-du-Saint-Sacrement, Paris, where it is now to be seen.

21 Exhibited in 1827 and now in the church of Saint-Paul-Saint-Louis.

22 Painted in 1836 and bought for the church of Nantua.

23 Painted by Paul Delaroche, 1838–1841. It represents the most celebrated artists of all nations, up to the end of the seventeenth century.

24 Painted by Ingres in 1827 for the ceiling in one of the galleries of the Louvre. It was removed in 1855 in order to be shown at the *Exposition Universelle*, and some years later was replaced by a copy. The original now hangs as a picture in the Louvre.

25 Delacroix made twenty allegorical paintings for the library of the *Chambre des Députes* between 1838 and 1847.

26 Delacroix was nearing the end of his work at the Luxembourg at the time that this was written.

27 Dante, *Inferno*, canto IV, lines 64ff.

28 The phrase italicized (by Baudelaire) is an exact verbal echo from Fénelon's description of Calypso's island (*Télémaque*, book 1).

29 In The Metropolitan Museum of Art, New York.

30 Reproduced Raymond Escholier, *Delacroix*. Vol. 3 (Paris, 1926–1929), facing p. 308.

31 Delacroix's *Faust* lithographs were first published in book form in 1828. Goethe had seen some of them two years before and spoke of them with great admiration to Eckermann (see *Conversations of Goethe with Eckermann*, Everyman edition., pp. 135–136). Between 1834 and 1843 Delacroix made sixteen lithographs of scenes from *Hamlet*.

32 Painted in 1838 and now in the Lille Museum.

33 Painted in 1841 and now in the Louvre.

34 Delacroix painted several versions of *Hamlet and the Gravedigger*: that of 1839 is in the Louvre.

35 Painted in 1840 and now in the Louvre.

36 Painted in 1834 and now in the Louvre.

37 The simile recurs in the stanza devoted to Delacroix in Baudelaire's poem *Les Phares*.

38 Frédérick Lemaître (1800–1876) was one of the great French actors of the Romantic generation. He made his first great success as Robert Macaire in *L'Auberge du Adrets* (1823) and later created the title role in Victor Hugo's *Ruy Blas*.

39 William Charles Macready (1793–1873), the notable English tragedian of the same generation as Edmund Kean. His grand, impassioned style greatly impressed the French when he acted in Paris in 1828 (twice) and again in 1844.

40 The note in the Salon catalogue runs as follows: "Cette vierge, ayant caché les livres saints, contre les ordres de l'empereur Dioclétien, fut mise en prison et percée d'une fleche" (Vies des Saints).

41 Now in the Autun Museum.

V

1 By Watteau.

2 CB I have been told that many years ago Delacroix made a whole mass of marvelous studies of women in the most voluptuous attitudes, for his *Sardanapalus*.

3 CB M. Ingres's *Grande* and *Petite Odalisque* are two pictures of our times which are essentially concerned with love, and are admirable, more-over. (Translator's note: The *Grande Odalisque* is in the Louvre; the *Petite Odalisque* is presumably the *Odalisque with Slave*, in the Fogg Art Museum, Cambridge, Mass.)

4 François Watteau (de Lille) (1758–1823), son of Louis Watteau and nephew of Antoine Watteau.

5 One of the series *Les Amants et les Epoux* by Tassaert. The lady's words are "Ne fais done pas la cruelle!"

6 CB "Sedebant in fornicibus pueri puellaeve sub titulis et lychnis, illi fae-mineo compti mundo sub stola, hae parum comptae sub puerorum veste, ore ad puerilem formam composito. Alter veniebat sexus sub altero sexu. *Corruperat omnis caro viam suam.*" Meursius. (Translator's note: This passage is quoted from Nicolas Chorier's *Aloysiae Sygeae satira sotadica de arcanis Amoris et Veneris* [1658], which purported to be Meursius's Latin version of a Spanish original.)

VI

1 George Catlin (1796–1872), the American artist, spent eight years with Indian tribes residing in United States, British, and Mexican territo-ries, between 1829 and 1837. During this period he painted some five hundred portraits and other pictures of Red Indians. During 1838 and 1839 he toured his collection in the United States, and then brought it to London, where he established himself at 6 Waterloo Place. In 1845 he visited Paris, bringing with him not only his paintings but several live Indians as well. One of these was *Shon-ta-yi-ga* or *Little Wolf*, whose portrait Baudelaire mentions here. See Alfred Delvau's *Lions du Jour* (1867), and also Catlin's *Descriptive Catalogue*, published by himself in London in 1848; it contains appreciations from the American, En-glish, and French press.

Catlin's collection is now in the care of the Smithsonian Institu-tion, Washington, DC; a small selection was brought to Europe and exhibited in 1954.

2 Reproduced *L'Illustration. Journal universel*. Vol. VII (1846), p. 56.

3 Reproduced *L'Illustration. Journal universel*. Vol. VII (1846), p. 121.

4 Laemlein made a lithograph also of this subject.

5 Of Decamps's four exhibits this year, one, the *Souvenir de la Turquie d'Asie* (catalogued as *Enfants turcs auprès d'une fontaine*, and incor-rectly assigned to 1839) is in the Musée Condé, Chantilly; the others are in the Fodor Museum, Amsterdam.

6 At one time Baudelaire considered him as a possible illustrator for *Les Fleurs du mal*.

7	This painting was Lot 59 at the Moreau-Nélaton sale, Paris, May 11, 1900; its present whereabouts is unknown.
8	Jean-Gaspard Deburau, the famous French pantomimist, died this year.
9	Presumably David Roberts, R.A., who is chiefly remembered for his Spanish scenes.
10	Diaz had eight paintings at the Salon this year, of which Baudelaire mentions the names of two. Another, entitled *Orientale*, is reproduced *L'Illustration. Journal universel*. Vol. VII (1846), p. 136.
11	In the Boulevard Montmartre.
12	The portrait was at the Salon of the previous year. This year Haffner exhibited three landscapes only, of which one is reproduced *L'Illustration. Journal universel*. Vol. VII (1846), p. 185.

VII

1 CB	Nothing absolute—thus the geometric ideal is the worst of idiocies. Nothing complete—thus everything has to be completed, and every ideal recaptured.
2 CB	I say *contradiction*, and not *contrary*; for contradiction is an invention of man's.
3 CB	Stendhal, *Histoire de la Peinture en Italie*, chap. 101. This was printed in 1817.

VIII

1	Now in a private collection (Georges Wildenstein, *The Paintings of J.A.D. Ingres* [London: Phaidon, 1956], 225).
2	See p. 27.
3	A grotesque hunchback invented by the caricaturist Traviès and much used by him and others in the 1830s.
4	In the Louvre (Wildenstein, 236).
5	I.e., *Roger et Angelique* (1819), in the Louvre (Wildenstein, 124).
6	In the Frick Collection, New York (Wildenstein, 248).
7	Exhibited by Henri Lehmann at the Salon of 1836.
8	Both reproduced *L'Illustration. Journal universel*. Vol. VII (1846), p. 184, and the *Illustrated London News*, May 23, 1846.
9	The Lyons school of painting was particularly deplored by Baudelaire.
10	Under this main title, Brillouin exhibited four drawings, with individual titles such as "Les présents de l'étranger" and "Le retour du bien-aimé."
11	Curzon exhibited five drawings illustrating Hoffmann's *Meister Martin*; five such drawings are now in the Poitiers Museum.
12	In *La Presse*, April 7, 1846. Gautier's praise of Ary Scheffer in this article must have especially disgusted Baudelaire: see pp. 110–111.
13	Salon of 1845.

14 Salon of 1846.
15 Salon of 1845: reproduced *L'Illustration. Journal universel*. Vol. V (1845),
 p. 152.

IX

1 This exhibition took place in January 1846.
2 Ingres's portraits of M. Bertin (1832) and of Cherubini (1841) are in the
 Louvre (Wildenstein, 208 and 236).
3 It is not quite clear to which straw-hatted lady Baudelaire refers: Cré-
 pet suggests a portrait of the Countess Spencer by Reynolds, but sev-
 eral others of Reynolds's portraits (e.g., *Nelly O'Brien*, in the Wallace
 Collection) fit the description.
4 Lawrence's *Master Lambton* was shown in Paris in 1827.
5 The reference is to Hoffmann's *Nachricht von den neuesten Schicksalen
 des Hundes Berganza*. Hoffmann had taken over the character of the
 speaking dog Berganza from a story by Cervantes.
6 The heroine of Mme de Staël's novel of that name.
7 In spite of her name, Mme O'Connell was born German.
8 Exhibited at the Salon of 1845.
9 Editor of *Le Globe*.
10 Now in the Musée Granet, Aix-en-Provence.

X

1 CB Somewhere or other Balzac spells it "chique."
2 The word is a slang derivation from *poncer*, "to pounce," in the tech-
 nical sense of transferring, and then of multiplying and perhaps vul-
 garizing, a design.

XI

1 The literal, unsarcastic meaning of the word is a writer of *vaudevilles*,
 i.e., light theatrical entertainments interspersed with catchy, popular
 songs.
2 *Le Moniteur universel*, founded 1789, and until 1869 the official govern-
 ment organ.
3 This year Horace Vernet exhibited a characteristically enormous pic-
 ture (roughly fifteen feet by thirty feet) of the Battle of Isly. It is now in the
 Versailles Museum.
4 The reference is to Béranger.
5 Literally "with a caul on his head," French: *coiffé*. CB: An expression of
 M. Marc Fournier's, which is applicable to almost all our fashionable
 novelists and historians, who are hardly more than literary journal-
 ists, like M. Horace Vernet. (Translator's note: Marc Fournier [b. 1818]
 was a popular playwright.)

6 CB "True memory, considered from a philosophical point of view, consists,
I think, in nothing else but a very lively and easily roused imagination,
which is consequently given to reinforcing each of its sensations by
evoking scenes from the past, and endowing them, as if by magic,
with the life and character which are proper to each of them—at least
I have heard this theory upheld by one of my past teachers who had
a prodigious memory, although he could not carry a single date or
proper name in his head. My teacher was right, and in this matter
there is, no doubt, a difference between sayings or utterances which
have embedded themselves deep in the soul and whose intimate and
mysterious meaning has been grasped, and words which have merely
been learnt by heart." Hoffmann.

7 Eugène Scribe (1791–1861), the popular dramatist of the mid-nineteenth
century.

8 Peter Cornelius (1783–1867), chiefly noted for his revival of fresco. From
1824 he was director of the Munich Academy.

9 CB Thus there is not one of M. Horace Vernet's canvases before which it
would not be appropriate to sing:
Vous n'avez qu'un temps à vivre,
Amis, passez-le gaiement.
The gaiety is essentially French. (Translator's note: These lines are by
the eighteenth-century French general, the comte de Bonneval.)

10 All of Granet's eight pictures at this Salon had religious subjects.

11 One of Dedreux's pictures, entitled *Chasse au faucon*, reproduced
L'Illustration. Journal universel. Vol VII (1846), p. 57.

12 One of the four pictures which Jean-Baptiste Jouvenet (1644–1717)
painted for the church of Saint-Martin-des-Champs; it is now in the
Lyons Museum, and a replica is in the Louvre.

XIII

1 Friedrich Overbeck (1789–1869), leader of the "Nazarenes." From 1810
he worked in Rome.

2 The Salon of 1846 was the last at which Ary Scheffer exhibited. The
painting of St. Augustine and his mother proved, however, to be one
of his most popular works, and he painted at least four replicas; one
is in the National Gallery [London], one in the Louvre, and one in the
Dordrecht Museum.

3 St. Augustine's *Confessions*, book 9, chapter 10.

4 A reference to Gautier's Salon in *La Presse*, in which he wrote that Mar-
guerite belonged to Scheffer almost as much as to Goethe himself.

5 Ary Scheffer's younger brother.

6 CB To those who must sometimes have been shocked by my pious wrath, I would recommend the reading of Diderot's *Salons*. Among other examples of properly bestowed charity, they will find that that great philosopher, when speaking of a painter who had been recommended to him because he had many mouths to feed, observed that either pictures or families would have to be abolished.

7 Baudelaire returns to the subject of titles in the *Salon of 1859*.

8 By Mme Céleste Pensotti.

9 By Charles Landelle.

10 By H.-G. Schlésinger.

11 By Eugène Giraud, exhibited at the Salon of 1839.

12 Jean-Nicolas Boullly (1763–1842), playwright.

13 The author of *Paul el Virginie*.

14 Compte Calix exhibited *L'Amour au château* and *L'Amour à la chaumière* (both reproduced *L'Illustration. Journal universel*. Vol. VII [1846], p. 89): Pierre Cottin exhibited *L'Amour à la ville*, an engraving after Guillemin.

15 Charles Richard's picture was in fact in *five* divisions: "le rendezvous: le bal: le luxe: la misère: Saint-Lazare."

16 This was perhaps A. Béranger's *La Charité*.

17 No. 42, rue Vivienne.

18 Victor Hugo's play about the famous courtesan of the seventeenth century was produced in 1831.

XIV

1 According to the Salon catalogue, this painting was commissioned by the Ministry of the Interior. Dominique Papety was for a while one of Chenavard's assistants.

2 In the Montpellier Museum.

3 This painting, entitled *L'Enfer de Dante*, is now in the Montpellier Museum. Chenavard was a high-minded and socially conscious painter—Silvestre called him "un orateur en peinture"—whose subdued color often approached *grisaille*. His *Martyrdom of St. Polycarp*, mentioned here, was exhibited at the 1841 Salon, and then placed in the church of Argenton-sur-Creuse (Indre). Comairas was also one of his assistants in a later project, entitled *Palingénésie Universelle*, for a series of *grisailles* to decorate the interior of the Pantheon: after three years the work had to be abandoned when the Pantheon was returned to the Church, in 1851. For a painter who came from Lyons, Baudelaire treats Chenavard with surprising respect. He was a close friend of Delacroix. See the article "Philosophic Art," in Charles Baudelaire, *The Painter of Modern Life and Other Essays* (London: Phaidon, 1964), pp. 204–212.

4 Reproduced *L'Illustration. Journal universel*. Vol. VII (1846), p. 221.

5	At the 1845 Salon.
6	Of Biard's eight exhibits, three are reproduced *L'Illustration. Journal universel.* Vol. VII (1846), pp. 152–153.

<div align="center">XV</div>

1	Baudelaire's remark is somewhat reminiscent of what Heine had to say some ten years before, in his *Letters on the French Stage*. Heine wrote: "I frequented the Théâtre-Français very little. That house has for me something of the mournfulness of the desert. There the spectres of the old tragedies reappear, with dagger and poisoned cup in their wan hands."
2	Entitled *Vue prise dans forêt de Fontainbleau*: now in the Boston Museum.
3	The previous year Aligny had published a set of ten *Vues des sites les plus célèbres de la Grèce Antique, dessinées sur nature et gravées par Théodore Aligny*. To judge by a remark in Theoré's *Salon de 1846* (edition of 1868, p. 371), it was eight of these etchings that Aligny exhibited this year.
4	Of Cabat's two exhibits, that entitled *Le Repos* is in the Louvain Museum.
5	Of Troyon's four exhibits, that entitled *Vallée de Chevreuse* is reproduced *L'Illustration. Journal universel.* Vol. VII (1846), p. 187.
6	Le Roux was a pupil of Corot's.
7	Français's *Etude de Saint-Cloud*, with figures by Meissonier, was in the Pourtalès collection. His *Effet de soleil couchant*, also exhibited, is in the Musée Fabre, Montpellier.
8 CB	At last I have found a man who has contrived to express his admiration for this artist's works in the most judicious fashion and with an enthusiasm just like my own. It is M. Hippolyte Babou. I think, as he does, that they should all be hung along the *flies* of the Gymnase. "*Geneviève* or *La Jalousie paternelle* is a ravishing little Meissonier which M. Scribe has hung up on the flies of the Gymnase": *Courrier français*, in the *feuilleton* of 6 April. This strikes me as so sublime that I take it that MM. Scribe, Meissonier, and Babou cannot but gain all three by my quoting it here. (Translator's note: It was Hippolyte Babou [1824–1878] who later suggested the title "Les Fleurs du mal" to Baudelaire. On Scribe, see section XI, note 7.)
9	Nevertheless the painting by Joyant reproduced in *L'Illustration* this year (vol. VII, p. 89) represented *Le Pont Saint-Bénezet, Avignon*. His other two pictures were of Venetian subjects.

10 Although he had had a moderate success at the Salon in the early 1830s, Théodore Rousseau's landscapes were consistently rejected from 1838 until 1849. He was nicknamed "Le Grand Refusé."

11 Gudin's thirteen exhibits this year ranged from landscapes to sea battles.

12 Reproduced *L'Illustration. Journal universel.* Vol. VII (1846), p. 120.

13 The correct title of Kiorboë's painting was *Un renard au piège, trouvé par des chiens de bergers.*

14 Saint-Jean specialized as a flower and fruit painter.

15 P. Rousseau's *Le chat et le vieux rat* was reproduced *L'Illustration. Journal universel.* Vol. VII (1846), p. 88.

16 The well-known dealer.

XVI

1 Like Théodore Rousseau, Auguste Préault was systematically refused by the Salon juries from the early 1830s until 1848. He was the Romantic sculptor *par excellence*, and was as well known for his wit as for his statuary.

2 I.e., David d'Angers.

3 The catalogue makes it clear that Cumberworth's *Marie* was the negress slave in Bernardin de Saint-Pierre's *Paul et Virginie.* Cumberworth was regularly employed by Susse frères, the dealers in decorative sculpture.

4 J.-F.-S. Provost; the bust is now at the Comédie Française.

5 Klagmann's plaster statue was entitled *Une petite fille effeuillant une rose.*

6 Pradier has been described as the Romantic sculptor of the "juste-milieu."

7 In the Nîmes Museum.

8 This is presumably Antoine-Laurent Dantan (1798–1878), though his younger brother Jean Pierre Dantan (1800–1869) also exhibited at this Salon.

9 This was Lenglet's first Salon.

XVII

1 CB I often hear people complaining about the theater of today; it lacks originality, they say, because there are no longer any types. But the Republican? What about *him*? Is he not an essential for any comedy that aims at being gay? And in him have we not a successor to the role of Marquis?

2 Victor Hugo, *Notre-Dame de Paris*, book 5, chapter 2, "Ceci tuera cela."

1 CB These two types of decadence must not be confused; one has regard to the public and its feelings, the other concerns the studios alone.

2 CB The first killed himself because he could no longer endure his burning shirt; the second, because there was nothing more that he could do for the cause of liberty; and the voluptuous queen, because she had lost both her throne and her lover. But none of them destroyed himself in order to change skins through metempsychosis.

3 Rousseau. The belief that he committed suicide is now considered to be without foundation.

4 The hero of Balzac's *La Peau de Chagrin*.

5 Dumas the elder's prose-drama *Antony* was produced in 1831. The central character became a powerful hero-figure of the times, and young men who cast themselves for this role in real life were popularly known as "Antonys."

6 Lami exhibited an oil painting, *La reine Victoria dans le Salon de famille au château d'Eu, le 3 Septembre 1843*, and a watercolor, *Le grand bal masqué de l'Opéra*.

7 See Baudelaire, *Painter of Modern Life*, pp. 182–183.

8 Barbey d'Aurevilly's *Du Dandysme et de George Brummell* had been published the previous year.

9 The reference is to Lacenaire (1800–1836), deserter, murderer, and rebel, whose career became a Romantic symbol for the revolt against society. The Abbé Montès was senior chaplain at the prison of La Grande Roquette.

10 Well-known characters from Balzac's novels.

11 The hero of Balzac's play *Les ressources de Quinola* (1842), which was set in the sixteenth century—the period of doublet and hose.

12 A few months before, Baudelaire had published a satirical article at Balzac's expense entitled *Comment on paie ses dettes quand on a du génie*. There occurred here a passage strikingly similar in form, but with a marked difference of epithet: "lui [Balzac] le personage le plus cocasse, le plus intéressant, et le plus vaniteux des personnages de la *Comédie humaine*, lui, cet original aussi insupportable dans la vie que délicieux dans ses écrits, ce gros enfant bouffé de génie et de vanité."